GARDENA POKER CLUBS

A HIGH-STAKES HISTORY

MAX VOTOLATO

THE
History
PRESS

Published by The History Press
Charleston, SC
www.historypress.net

Copyright © 2017 by Max Votolato
All rights reserved

Front cover, clockwise from top left: Promotional photo of high rollers in the Normandie Casino's VIP King Dragon Room. *Blaine Nicholson*; The Horseshoe Club. *City of Gardena Archives*; The New Gardena Club and Four Queens Bar, 1980s. *City of Gardena Archives*; Ernest Jay Primm. *City of Gardena Archives*; Normandie Club chips. *Miller family archive.*

Back cover, left: The original six. *City of Gardena Archives*; *right*: Rainbow and Monterey Restaurants ad. *Blaine Nicholson.*

First published 2017

Manufactured in the United States

ISBN 9781467136716

Library of Congress Control Number: 2017931816

Notice: The information in this book is true and complete to the best of our knowledge. It is offered without guarantee on the part of the author or The History Press. The author and The History Press disclaim all liability in connection with the use of this book.

All rights reserved. No part of this book may be reproduced or transmitted in any form whatsoever without prior written permission from the publisher except in the case of brief quotations embodied in critical articles and reviews.

For Gregory, Danuta, Phoebe and Rosemary

CONTENTS

Introduction	7
1. Gardena of Eden: Origins and the Legalization of Poker	9
2. Boomtown	26
3. Wild Card	55
4. Public Relations	86
5. Poker Capital of the World	102
6. Death of the Card Clubs	116
7. Hustler	139
Epilogue	151
Sources	153
Index	157
About the Author	160

Gardena is centrally located to all points in the Los Angeles Metropolitan Area. *City of Gardena Archives.*

INTRODUCTION

Visiting Gardena today, it's hard to imagine that this sprawling California suburb was once considered the "Poker Capital of the World." Gardena's contemporary boulevards still bear glitzy neon façades, but the reign of card clubs and twenty-four-hour nightlife has given way to new gated communities, corporate strip malls, department stores, manufacturing plants, Asian restaurants, burger joints and taquerias.

At the turn of the twentieth century, immigrant Japanese families worked the land—known as the garden spot—producing, among other things, strawberries, raspberries and blackberries from the fertile soil of their truck farms. These early farmers used the local railway to ship their produce into Los Angeles on a daily basis. This led to Gardena—for a time—being dubbed "Berryland," the berry capital of Southern California.

But by September 11, 1930, when Gardena incorporated within its boundaries the rural communities of Gardena, Moneta and Strawberry Park, Gardena's berry industry had declined while other crops had been cultivated during World War I to help the war effort. With a dwindling agricultural industry and the profitable strawberry crops virtually gone, the newly minted city faced the dilemma of where to turn for another income stream. It was at that point Gardena's interests switched from skilled farm labor to games of skill. That is the subject of this book.

1
GARDENA OF EDEN

ORIGINS AND THE LEGALIZATION OF POKER

Ernest "Ernie" Primm was born on September 4, 1901, in Moulton, Texas. The Primm family moved to Los Angeles when Ernie was eight years old and lived on Bronson Avenue in Hollywood, California. His father, Julian Bismark Primm, a former oil man, opened a wholesale confectionery. After graduating from Hollywood High in 1919, Ernie went to work for his father's business until he saved enough money to start his own small café.

During the Great Depression, Ernie became involved with the Los Angeles street scene, a perfect training ground for the young, street-smart entrepreneur. There, Primm and his partner, Joseph "Frankie" Martin, opened and operated a series of illegal underground casinos. These casinos included a gambling club on Washington Boulevard near Hoover Street and later the Edgemont Club, which existed above a coffin factory on 18th Street and Flower. It is important to note that these early Primm operations were illegal casinos and not the strict "card clubs" he later became famous for in Gardena. These illegal casinos featured craps, blackjack, roulette and many of the gambling games played in Las Vegas casinos.

Russell "Russ" Miller, a longtime Primm associate who later owned Gardena's Normandie Club, began his career manning the door at the Edgemont Club. One night, when Miller admitted a police captain who was well known to the club's staff, everyone playing at the tables inside suddenly tried to get out because they thought they were being raided. Miller later graduated to being a boxman, supervising games on the craps table.

All of this was possible because 1930s Los Angeles was a bastion of corruption and vice. The city, founded in 1781 as a Spanish pueblo, had evolved into a sin city where narcotics, prostitution and gambling ruled. In July 1933, Los Angeles voters elected Canadian-born Frank Shaw as mayor. Shaw had previously served on both the city council and the board of supervisors. At a time when the city's most poverty-stricken citizens stood in bread lines and lived in shantytowns and flophouses, Mayor Shaw and his brother Joe wasted little time ushering in a world-class era of corruption through the machinations of city hall. Money talked, and virtually everything was for sale. One could even buy his way into a job as a policeman. Rumors circulated that the Shaw brothers had deep connections with all the powerbrokers of the Los Angeles underworld.

Pulitzer Prize–winning journalist Carl Greenberg, who worked as a reporter and later a political writer for both the *Herald Examiner* and the *Los Angeles Times*, described Shaw-era Los Angeles: "There were houses of prostitution all over town…[and] gambling joints. Slot machines could be found in the rear of many restaurants. Pinball machines that paid off in cash helped pay the rent in many small business establishments. Bookies were tripping over each other."

A host of nightclubs and "speaks" were dotted around the county. This list included prominent clubs, such as Club Airport Gardens, located near the city limits of Glendale; the Clover Club on Sunset Boulevard, just outside the city limits; the Marcell Inn in West Altadena; and the New Colony Club in Culver City. There was also a score of lesser-known clubs that would feature one to three roulette wheels, a blackjack table or two and, in some, a green craps table. Most of these clubs were simple "sawdust joints"—less sophisticated establishments than their swanky "carpet joint" counterparts—but they drew a steady stream of willing players.

Shaw's empire began to crumble in 1937, when one of his water and power commissioners was convicted of running a protection racket, along with the indictments of brother Joe Shaw and police lieutenant Pete Del Gado for selling city jobs, including positions in the police and fire departments. Del Gado fled to Mexico, leaving Joe Shaw to be found guilty on sixty-three felony counts. Reformists led by California restaurateur Clifford Clinton were soon urging voters to support a recall election to remove Shaw from power. The electorate agreed, and only a few brief months into his second term, in the fall of 1938, Shaw became the first mayor of a major American city to be recalled from office. He was succeeded as mayor by reformist Superior Court judge Fletcher Bowron. Bowron went on to earn the distinction of being the

city's second-longest-serving mayor after Tom Bradley (1973–93). His Los Angeles Urban Reform Revival initiative included replacing Police Chief William Worton with William H. Parker in 1950 as an attempt to clean up rampant corruption within the Los Angeles Police Department (LAPD).

Bowron's mayoral assault on the Los Angeles underworld drove professional gamblers out of the city and resulted in a surge of business in Las Vegas, including a casino boom. Even before the City of Los Angeles cracked down on illegal gambling, Primm, Martin and Miller had decided to retreat from the inevitable jaws of reform. Primm had a loose connection to Gardena's first mayor, Wayne Bogart, the owner of an automobile agency who served as Gardena's mayor for eleven out of his thirteen years on the city council, which led to the trio taking their rogue gambling operation fifteen miles south to the small Los Angeles County town of Gardena.

During the mid-1930s, Gardena was a farming community featuring strawberry farms, alfalfa fields and dairies. The city had a small population of approximately three thousand people, including a large Japanese American community. Primm, Martin, Miller and Joseph Hovespian (aka Joe Hall) arrived in Gardena in 1936, and that summer, an ordinance was introduced by Councilman Earl Powers governing the regulation of public skill games, among them a game called "Skillo." Skillo and a similar game called "Tango" were popular at the time and played openly at local beach resorts. The new regulation was put to a vote on August 6 and passed with a 4–1 majority. A new ordinance was quickly drafted by City Attorney Lester Luce, stating, "Nothing can be construed as permitting gambling or lottery, and games must be operated in full conformity with the laws of the state, city and county."

Meanwhile, protests against it were filed by the Gardena Ministerial Association, the Woman's Christian Temperance Union and the congregations of the Presbyterian and Baptist churches. Despite a referendum petition against the ordinance by the Southern California Initiative and Referendum Bureau that allegedly bought signatures for ten cents each and an attempt by Gardena councilman F.M. Sever to repeal the legislation permitting the operation of skill games, both efforts failed for lack of support.

An immediate slew of applications for club permits ensued, and in September 1936, Primm and Martin announced the opening of Gardena's first Skillo club: the Embassy Palace. It was located on Vermont Avenue at the southern end of today's Hustler Casino parking lot. The vacant building, formerly the site of a cinema called the Embassy Theatre, had undergone a $20,000 remodel in preparation for opening. Ernie Primm met his first

wife, Josephine Schmitz, at the Embassy Palace, and on December 22, 1936, the couple were married in Las Vegas. Prior to meeting Primm, Josephine had been the club's coat and hat check girl, earning a meager $28 a week. During their marriage, they had five children and lived in the elegant San Gabriel Valley suburb of San Marino.

Resistance to gaming establishments continued in the form of a letter-writing campaign designed to bring the problem of juvenile delinquency—aggravated by minors being admitted to local clubs—to the attention of the Gardena City Council. A *Gardena Valley News* article from the spring of 1937 titled "Gaming Evil to Be Target of Clean-Up" described how the effort was brought about by members of local church and PTA groups as well as other civic organizations within the community. Their letter-writing campaign began at a meeting held at the home of Mrs. William Mowatt in response to allegations by church leaders and citizens that local high school students were circulating membership cards for one of the two alleged gaming houses.

However, by May 1937, the threatened war against gambling in Gardena had not lived up to the promised peak of interest for the city council. The protest letters only offered vague information and a lack of any definitive recommendations to the council.

While some of their former competitors bought gambling ships and ran them out of San Pedro—attempting to circumvent the law in the wake of the Los Angeles reform movement—Primm and his partners relocated the illegal side of their operation to a pool hall called the Gardena Billiard Parlor, on Gardena Boulevard, where they were able to conceal and operate some poker tables. They also began operating an illegal casino behind the unassuming front of a candy store called the F&O Confectionery, a reminder of Julian Primm's first L.A. business, located at Redondo Beach Boulevard and Vermont Avenue.

Russ Miller was tasked with operating the phony candy store and letting in only real gamblers. Primm had stocked the shelves with candy to mask the gambling charade. But long hours minding the shop led to Miller and his henchmen eating the candy. To disguise the lost inventory, they would fill the empty wrappers with bits of cardboard and return them to the shelves. On one of his visits to the shop, as Primm himself reached for a candy, Miller quickly concealed the misappropriation of stock by fibbing that it was all stale: "You don't wanna eat that!" Behind its phony front, F&O Confectionery featured Vegas-style games, including slot machines and poker tables offering ten-cent-limit games. Players also paid a collection fee

of ten-cents every half hour for the use of each seat at the poker tables. The operation earned approximately $15,000 per month.

Primm hired a valet to park the players' cars away from the establishment to conceal the number of customers. But soon word got out, and on June 2, 1937, the F&O Confectionery was raided by the authorities. Reverend J.L. Bogue, a former pastor of the Gardena Baptist church and a member of the Los Angeles Grand Jury, accompanied Gardena police that night on a series of raids on local gambling spots, including the Gardena Billiard Parlor. Nothing but a small poker game was found in session at the F&O Confectionery, but six arrests were made at the Gardena Billiard Parlor. Those arrested received suspended fines of $100 and $75 issued by Gardena judge Elmo Morris for dealing and conducting a gambling game, indicating the city's reluctance to enforce penalties for gambling.

On November 20, 1937, the Embassy Palace was the target of a Saturday-night raid conducted by Gardena's first ever police chief, George Norman, and a group of eight deputies led by Captain George "Ironman" Contreras of the county sheriff's office. The raid resulted in the discovery of some two hundred patrons who were playing Skillo. Proprietor Frankie Martin and twenty-three employees, including a number of Gardena residents, were arrested. Judge Frank Carrell fixed Martin's bail at $100 and bail for each of the employees at $25.

Three days later, all twenty-three employees of the Embassy Palace stood before Judge Carrell at the Inglewood Township Justice Court and entered pleas of not guilty to charges of operating a lottery. Attorney Sam "Sammy" Rummel represented them and requested that the court schedule an immediate jury trial to lessen any unnecessary hardship for the employees, who all believed Skillo was legal. Rummel—who at one time was well known as Mickey Cohen's lawyer—was a flamboyant man who always dressed impeccably. His colorful courtroom presentations often included wardrobe changes. Sometimes, in the middle of a trial, he would interrupt his arguments in order to change his shirt or even his suit.

The fact that Captain Contreras and his deputies had considerable difficulty determining if Skillo was really gambling was evidenced by Martin's statement that "the deputies were on hand each night since the opening Wednesday of last week. They played the game nightly but did not decide to arrest anyone until last Saturday evening."

Martin contended that Skillo was, in fact, a game of skill:

> *We expect to prove to the satisfaction of a jury that our game is really one of skill.... If we are successful in proving that point we shall immediately reopen and if we are further molested by the officers, we will sue them for damages and carry the case to the California Supreme Court if necessary to establish the fact that our game is really a game of skill.*

When questioned as to why he thought Skillo to be a game of skill, when Tango, a similar game, had already been deemed illegal by Attorney General Ulysses Sigel Webb, Martin replied:

> *The only similarity to Tango in our game is the fact that numbered boxes are used. Each player has his own individual set of numbered boxes and throws balls into them. He can only win if he throws the balls into the proper boxes himself. He cannot win on what some other player may be doing. This removes the element of chance. Many players become quite skillful and accurate in their aim so that they easily win over less skilled players.*

The brief trial was expected to have an important bearing on the operation of skill games throughout Los Angeles County and the attitudes of law enforcement officers toward skill games. As such, it was run in the nature of a test case. Prosecuted by Deputy District Attorney Thomas O'Brien, the trial began on December 1, with ace investigator Rittenhouse of the sheriff's office taking the stand as the star witness for the prosecution. Rittenhouse testified for over an hour under O'Brien's questioning about the type of game played at the Embassy. Rummel, representing the defendants, skillfully cross-examined Rittenhouse to prove that no player could win at the game of Skillo except by his own effort or skill in throwing a ball into the correct compartment in a group of boxes.

In reaching his own conclusion that the game was one of skill, Judge Carrell compared it to the game of horseshoes, in which significant skill is required to make "ringers." In the game of Skillo, a person could develop considerable skill in throwing the ball into the proper compartment in order to win, whereas a person less skilled in the game might not be able to win at all. In the end, it took the jury only five minutes to reach a verdict of not guilty, quickly determining that Skillo was just what the name implies—a game of skill.

Unsatisfied with the lottery charge acquittal, Captain Contreras led another raid on the Embassy Palace the following Saturday night, forcing

another trial for the same charge. Contreras, who was determined to have the opinion of more than one judge as to whether or not Skillo was really a game of skill, took proprietors Frankie Martin and Samuel Evans and sixteen employees into custody.

Deputy Attorney General Henry Dietz accompanied sheriffs on the Embassy Palace raid and claimed to have found a notebook containing a list of names and addresses of city officials and judges scheduled to receive Christmas gifts from the establishment. When the press questioned him about the notebook, Martin denied any knowledge of it but stated jokingly that, if a book like that was found, the club would make sure that anyone listed in it would not be disappointed. Martin ribbed, "Of course, if they keep on arresting us, we may be too poor to send Christmas gifts, but in that case we'll see that officials get Christmas cards at least."

Both prosecution and defense lawyers agreed to a new trial without a jury, and on December 18, the Embassy Palace was used as a temporary courtroom so Judge William Gallagher of the Venice Township Court could view a two-hour private practical demonstration of the game, Skillo, as it was customarily played. Interested spectators at the event included deputy district attorneys and a group of sheriff's deputies. In an effort to prove that they were operating a game of skill, the proprietors of the Embassy Palace brought in five better-than-average Skillo players as part of the demonstration. Judge Gallagher watched them play the game and requested that they throw certain numbers. When the players complied, he took careful note of the number of balls they had to throw to obtain the requested numbers. This indicated that the judge was taking mathematical probabilities into consideration as part of his decision-making process. When the players were given the opportunity to pick their own numbers, they were able to toss the balls into the correct box in as few as three throws.

Defense attorney Rummel took the opportunity to suggest that a regular game of Skillo be played between the five house players and five sheriff's deputies who contended it was purely a game of chance. The judge readily agreed to Rummel's proposition, but the deputies seemed reluctant to enter the contest. The group played four games, with the house players winning three of the four. These results supported and once again proved the defense's argument that this was indeed a game of skill. Judge Gallagher even took a hand in the game himself but apparently had no more skill than the deputies and prosecuting attorneys.

On January 3, 1938, Judge Gallagher handed down his decision, surprisingly ruling in favor of the prosecution, finding the eighteen

GARDENA POKER CLUBS

defendants guilty on grounds of operating a lottery and that the game of Skillo contained elements of both skill and chance—with the element of chance predominating. It was impossible for an appeal to be taken from Gallagher's decision because there was no transcript of the evidence kept at the trial. Despite Rummel's plea for a new trial, Judge Gallagher pronounced his sentence, fining Martin and Evans $100 each. The judge intimated in his sentencing that if some changes were made to the game, it was possible that it could become legal. Martin indicated that they would probably follow the judge's advice and make changes in order to operate Skillo again at the Embassy Palace, stating:

Ernest Jay Primm. *City of Gardena Archives.*

> *We have no intention of trying to operate an illegal game, but our attorneys have advised us that our game is legal. A township judge and jury have found it legal and then Judge Gallagher comes along and decides its illegal. Naturally, we are confused, and we want the question definitely cleared up.*

In early 1938, Primm stumbled upon the idea of operating commercial draw poker parlors with the near-biblical revelation of a legal loophole that paved the way for his future poker empire. Upon visiting a Santa Monica bingo parlor that openly operated draw poker, Primm inquired how this could be possible without the law intervening. The proprietor suggested Primm "read the law. It doesn't say in there that 'draw poker' is illegal."

California senators who wrote the original 1872 statute outlawing gambling didn't want to put themselves in a position where they couldn't play poker. The result was legislation that listed every gambling game of chance imaginable—but not poker. An 1891 revision added the casino game "stud horse poker" to the long list of prohibited games, but in 1911, Attorney General U.S. Webb, a Republican who served for nine terms as the nineteenth California attorney general—from 1902 to 1939—clarified the law, publishing an opinion that draw poker, a game of skill and science, was exempt from anti-gambling laws because the cards weren't dealt face up as they were in stud. Therefore, draw poker couldn't be considered an illegal game.

A High-stakes History

With this in mind, Primm's partner Frankie Martin approached the Gardena City Council in June 1938 with a proposal to grant the Embassy Palace a license to operate draw poker. Martin promised that, in return, the cash-starved city would receive the benefit of yearly surcharges totaling fifty dollars for the first table and thirty-five dollars for every additional table they installed in the club. The councilmen agreed, and in July, the Embassy Palace began with forty tables offering legal games of draw poker. A newspaper advertisement for the club touted the many attractions of the Embassy Palace, including distraction from daily cares, the comfort of air conditioning, luxurious surroundings, a sober and congenial clientele, affordable deluxe chicken and steak dinners and attentive floormen

Embassy Palace Club newspaper ad. *City of Gardena Archives.*

ensuring fair play. The advertisement went on to describe the spirited atmosphere of the club's interior: "The shuffling of cards and the click of chips reverberates through the building while spectators stand and tensely watch the playing of a hand of poker, and whether you win or lose, a hundred years from now you will never know the difference."

Meanwhile, civic leaders outside Gardena rejected the idea of legalized card clubs. That summer, Gardena's more conservative neighbor, the City of Torrance, denied an application for a card club. In response to claims that his city was losing lots of revenue by not licensing poker clubs, Torrance mayor William H. Tolson replied, "Maybe the city is [losing money], but unless they go out of town to play poker, our residents are not." Newspaper headlines publicized the nefarious dangers of playing draw poker. One article, "English Squire a Piker at Poker," reported how a wealthy English sportsman, Henry Clifton, lost $150,000 in a Long Beach hotel room poker game, asserting to authorities that he had been given a "raw deal" and accusing actress Fanny Brice's brother Lew and three others of having "taken him." The incident was investigated by the Los Angeles District Attorney's Office, but nobody expressed sympathy for Clifton's alleged heavy losses.

Gardena police chief Norman, who vehemently opposed the card clubs, resigned in 1938 in frustration over the city's new acceptance of commercial draw poker. Chief Norman's replacement was Elmo Field, a former bookkeeper for the Embassy Palace whom the city claimed had been an Arizona highway patrolman. In reality, Field had only achieved the rank of chauffeur, having been the personal driver for Arizona's first governor, George Hunt, for which he received a highway patrolman's badge. Field did not actually serve as a police officer until 1938, when the City of Gardena appointed him police chief, a position he held until 1960.

On November 5, a vice squad of deputy sheriffs led by George Contreras swooped down on the Embassy Palace as part of a countywide raid on poker clubs prompted by a reversal of Attorney General Webb's 1911 opinion exempting draw poker from anti-gambling laws. The raids, on approximately twenty such establishments, were the result of a conference Webb held with the mayors and police chiefs of Los Angeles County cities, including Gardena, Hawthorne, Redondo Beach and Long Beach.

Webb's March 1, 1937 opinion ruled in a letter to the Modesto district attorney that commercial draw poker, where it was not operated as a bank or a percentage game, was legal in that there was nothing in state laws prohibiting it. Gardena's city council had passed its ordinance regulating the games and fixing license fees on the strength of this ruling. But during the

conference, Webb reversed his earlier rulings, telling the mayors and chiefs to close down the poker clubs. Gardena's Mayor Bogart noted that Webb refused to be pinned down by the issue of whether or not clubs charging by the hour for use of equipment were in violation of the law. Bogart commented that he personally saw no reason why the clubs were illegal, as he had copies of Webb's earlier opinions. Nevertheless, he ordered that the Embassy Palace be closed in line with Webb's latest ruling so that its legality could be determined by the courts.

Accounts of the Embassy Palace raid detail how sheriffs backed up large moving vans to the front door and began loading them with the club's equipment. No arrests were made, but sheriffs ordered several hundred players to cash in their chips and leave the premises. Earlier that day, under instructions from Mayor Bogart, Chief Field visited the club, arresting Frankie Martin and floorman Jack West on charges of operating a gambling establishment. Primm, acting on advice from attorney Sammy Rummel, chose to keep the Embassy Palace open, resulting in the sheriffs' padlocking the club's doors in a full-scale raid later that night and Primm's subsequent arrest.

Months of litigation followed, with Judge Carrell finding the establishments legal and dismissing the charges. On November 21, 1938, Judge Carrell acquitted Primm and two other poker palace operators of "operating and conducting draw poker as a banking and percentage game," ordering the return of the Embassy Palace's confiscated equipment.

Judge Carrell ruled that the evidence did not support the charge, stating that he had based his decision on Attorney General Webb's original ruling that draw poker was legal. This ruling was in direct conflict with the current edict from the District Attorney's Office ordering the closure of all Los Angeles County poker clubs. The justice court magistrate cited that the only way to stop the poker games being operated would be by an act of legislature amending the penal code to make draw poker illegal. This made Judge Carrell's ruling the first of its kind in Los Angeles County.

A month later, Deputy State Attorney General Paul McCormick fought back with a civil suit, closing the Embassy Palace with a restraining order on grounds that it constituted a public nuisance that affected the public welfare by attracting 1,500 patrons daily, many of whom traveled long distances from various parts of the county for the sole purpose of wagering money on the games played. This latest attack by state authorities was designed as a precedent for a bigger campaign to be lobbied against the card clubs. But before the case could be heard, a new state attorney general took office on

January 3, 1939. He was Earl Warren, future governor of California and chief justice of the U.S. Supreme Court.

Later that day, Deputy Attorney General McCormick and Embassy Palace defense attorney Roland Swaffield made their arguments before Judge Emmett Wilson. As Judge Wilson slowly pondered his decision, city attorneys in municipalities throughout Los Angeles County waited anxiously for the ruling. The verdict finally came in early February, determining that establishments permitting betting activities were illegal, constituting a public nuisance and could be shut down—even though the game of draw poker itself was considered legal. In comparison, parimutuel betting at horseracing tracks was specifically permitted by law and not subject to this ruling.

Judge Wilson concluded by handing down a permanent injunction banning the Embassy Palace and two other clubs in Hawthorne (the Elite and Hawthorne Clubs) from operating draw poker. In doing so, he stated that it was the duty of law enforcement to protect communities from any kind of nuisances and that city ordinances, such as the one Gardena used to license the Embassy Palace, were limited by state law. The decision did not consider the views of Gardena's residents, as no evidence was heard from the community as to whether or not the Embassy Palace's operations truly constituted a public nuisance. Even after the legal precedent established by Judge Wilson, his ruling was largely ignored, leaving the matter in the hands of local officials and local law enforcement.

During this period, the once brilliantly lit Embassy Palace sat dark, awaiting a more favorable outcome in the state's courts. Primm told the press that even after the judge's ruling, the case was far from over. That April, Primm and his partners took their appeal to the Supreme Court. However, their request was denied, as the Supreme Court ruled that commercial draw poker, even under the guise of a "game of skill," was still illegal.

Even though the Embassy Palace had been directly targeted, the issue of banning card clubs in Gardena was overlooked by the local government, and in the summer of 1940, Gardena police chief Field issued a skill game license to L. Bernstein for $365, permitting a new ten-table card club in the former California Ballroom building at 14808 South Western Avenue called the Western Club. Bernstein paid a $50 annual fee for the first table and $35 per table for the additional nine tables. A second skill game license was issued to Ballard and Cooley, owners of a new twenty-table card club called the Gardena Club, located in a newly completed seven-room, 4,300-square-foot building at 15460 South Western Avenue, which cost $8,600.

A High-stakes History

The Gardena Club opened for business in September 1940 and paid the city an all-time high fee of $715 for its twenty-table card club license. When Ballard and Cooley applied for the license earlier that year, in June, they were denied over the fact that their new building for the club had not yet been built. During the interim, the city council passed an amendment to the business license ordinance, raising the fee for skill game licenses.

The club had only been in operation for one week when it was hit, along with the other clubs, with an abatement notice of being a public nuisance. The new legal campaign was launched by District Attorney Burton Fitts and Judge Wilson, who signed the restraining orders as nine injunction suits were filed in Los Angeles Superior Court against poker clubs in Gardena, Hawthorne and Redondo Beach. This was the first time the card clubs had been targeted since Attorney General Earl Warren had forced the closure of the offshore gambling ships in Santa Monica Bay during the summer of 1939.

By December 1940, the Embassy Palace, now being advertised as the "Under New Management" Embassy Theatre, had reverted back to being a cinema, with fifteen-cent seats for screenings of *Wagons Westward* and Jack Benny and Joan Bennett in *Artists and Models Abroad*. The theater, an elegant popcorn palace originally built in 1929, had one screen and 550 seats.

Meanwhile, Primm had moved his operation to Western Avenue at 182nd Street. Frankie Martin obtained a license from the city and—at significant cost—leased, renovated and furnished an old barn with poker tables and other card club paraphernalia, turning it into the Monterey Club, which Primm and Martin ran with Russ Miller, who was now an actual partner in the business.

The new club licenses permitted members to engage in lawful games of cards, including draw poker, low ball, checkers, dominoes and other recreational activities. They also allowed for clubs to serve nonalcoholic beverages, tobacco, sandwiches and other light meals. In return for providing the facilities and furnishings, the clubs charged their members a fee. During a low ball game, every half hour, attendants would come to the table and collect a twenty-five-cent chip from each player. This fee was considered the players' rent for their seats at the table. During draw poker games, attendants would collect two five-cent chips for rent.

Games of low ball required that before every hand, each player would ante five cents and cards would be dealt out one at a time until each player had five. There were no house dealers. Everybody at the table dealt, and the dealer rotated, with the player to the immediate left of the dealer opening

first. Fifty cents was the minimum and maximum bet allowed, with as many raises and re-raises allowed as the players wanted. Players who met the opening bet drew cards; then it was up to the players whether to check or bet, and the lowest valued hand won the pot.

Standard draw poker also had the player immediately to the left of the dealer opening the pot. There was no "banker" to conduct the game or bank a percentage thereof. Each player would ante five cents before the deal, and the pot could be opened with jacks or better, with a minimum and maximum bet of twenty-five cents and fifty cents, respectively. There was also no limit on the number of raises and re-raises allowed. Ultimately, the best high poker hand won the game.

No actual money was used during games, and players purchased poker chips from the cashier's cage in order to play. Chips came in denominations of five, ten and twenty-five cents and were redeemable for cash at the cashier's window. The clubs also provided a staff to service and provide security for the members, retaining the right to refuse admission to anyone deemed to be violating the rules of conduct set by each club's board of directors, including anyone exhibiting loud, obnoxious or boisterous behavior.

The Gardena City Council amended its card club ordinance in January 1941, restricting anyone under the age of twenty-one from playing in a licensed poker club and tightening the clubs' operating hours to between 10:00 a.m. and 4:00 a.m. Mayor Bogart reinforced the ordinance, stating that since playing draw poker was not forbidden by legislative statute, licensing poker clubs under authorization of the municipal code in the city of Gardena could not be considered unlawful. According to the ordinance, clubs would not be liable to abatement, so long as they complied with the restrictions.

But by mid-March 1941, Primm and attorney Sammy Rummel were back in court. This time, they appeared in Division One of the District Court of Appeals, fighting a new injunction issued by Judge Wilson that prohibited playing poker at the Monterey Club. Wilson was once again declaring Primm's enterprise an illegal public nuisance. Rummel's petition pointed out that there were now more than five hundred draw poker clubs across the state of California, with over 200,000 active poker players. By late June, the Monterey Club was granted temporary permission to resume its operations, securing a writ of prohibition from the District Court of Appeals. The Monterey would be allowed to resume its activities until August, when Judge Wilson was scheduled to appear before the district judiciary body to show why the writ of prohibition should not be made permanent.

A High-stakes History

As the District Court of Appeals case extended into the fall of 1941, the sheriff's vice squad raided the Monterey and Gardena Clubs on charges of soliciting gambling patronage through the mail. The raids were prompted by complaints from Glendale resident N.P. Walton, who asserted he had received mailers from the clubs inviting him to play poker. Primm, Martin and Frank Cogswell of the Monterey Club were arrested along with Clarence Philbin and Lester Tupper of the Gardena Club. As club patrons were dispersed from both clubs, sheriffs proceeded to impound everything that wasn't nailed down, including chairs, tables and poker paraphernalia, as well as both clubs' records and membership files. Misdemeanor warrants were issued by Glendale police judge F.H. Lowe, with the defendants facing a maximum of six months in jail or a $500 fine.

After being found guilty of the charge, Clarence Philbin opted to spend thirty days in jail rather than pay a $100 court fine. The Gardena Club trial would be considered a test case for the Monterey Club's impending trial for the same charge, now scheduled for mid-February 1942. An appeal by Philbin in Superior Court failed, as the appellate court upheld the conviction for solicitation.

On November 28, 1941, Primm, Martin and Rummel finally got the opportunity to take their petition to the Superior Court. The day-long trial revealed that the Monterey Club had been set up as a nonprofit corporation with articles of incorporation that offered this mission statement as its primary purpose: "To promote, advance and maintain good will and harmonious action among the individual members." According to the club's bylaws, all of the approximately four hundred members had passed a screening process determining their eligibility by way of investigating each applicant's character, reputation and habits.

One of the most impressive parts of the petition was how Primm, Martin and Rummel were able to bring an extended cast of characters from the city of Gardena to testify on their behalf. Starting with affidavits from Monterey Club members Russ Miller and Frank Cogswell, the court went on to hear supportive testimonies from Gardena fire chief Don Parrott, who confirmed that the premises of the Monterey Club were top notch in all respects and the nature and character of the club's activities were always orderly and non-disruptive to the community. Gardena police chief Field also supported claims that the club had always conducted itself in a strict and orderly fashion, adding that due to the adequate parking facilities provided, there had never been a traffic congestion problem around the club. An affidavit from Gardena mayor Bogart, corroborated by Gardena

city councilmen Earl Jacobs and Earl Powers; along with P. MacDonneil, secretary of the Gardena Valley Chamber of Commerce; and Lewis Guild Jr., editor for the hometown newspaper the *Gardena Valley News*, echoed the mayor's remarks, stating that the Monterey Club had been "a credit to the community" since its establishment.

Rummel cited the Municipal Corporations Act of 1935, which stated that any ordinance passed by a city within the scope of its own authority had the same force within its city limits that a statute passed by the legislature had throughout the state. The act also authorized municipalities "to license for the purpose of revenue and regulation all and every kind of business authorized by law…and lawful games carried on therein." By that rationale, the City of Gardena was authorized to pass the ordinance and license the playing of draw poker. Rummel's skillful presentation established without contradiction that none of the hazards designated in the California nuisance statute were present in the operation of the Monterey Club, quoting Chief Justice Beatty's 1895 ruling: "Poker, played for money, however objectionable in fact, is, in the eyes of the law, as innocent as chess or any game played for simple recreation; and its votaries, and the places where it is played, are not criminal."

Bringing an end to the long series of lawsuits, raids and conflicting legal opinions, the California District Court of Appeal ruled that draw poker was legal in California and the City of Gardena was authorized to license and regulate the operation of card clubs within its corporate limits. Associate Justice Thomas White wrote in his opinion that "gambling is neither unlawful per se nor a public nuisance per se in California. Playing at any game, even for money, is not in itself an offense at common law. The offense, if any, must be created by statute, and can only be punished as the statute directs."

As a result, the Monterey and Gardena Clubs' confiscated equipment was returned. The decision marked the first time that the higher court had ruled on the question, vindicating both Judge Carrell, who had ruled early on that draw poker was legal in California, and Gardena city attorney Lester Luce, who had drafted the city's ordinance. During those lean war years, it also paved the way for Gardena to grant more card club licenses, including the January 1942 opening of the Embassy Club. The Embassy license was issued to the new partnership of George Distel, Frank Irvine and Archie Sneed Jr., converting the Embassy Theatre into a poker club.

A February 1942 amendment to Gardena's card club ordinance permitted a limit of one club for each 1,500 residents. The 1940 federal census figures show Gardena had approximately 6,000 citizens. This

meant that any further applications for card clubs beyond the existing four would automatically be denied. The amendment followed in the footsteps of neighboring city Hawthorne, which had already taken steps to limit the number of card clubs licensed within city limits. With the legal operation of four multi-table clubs in Gardena—the Monterey, Gardena, Western and Embassy Clubs—along with a one-table permit granted to the Twin Palms Club, the *Gardena Valley News* commented, "In as much as there are already four multiple table licenses issued, no more could be granted unless it were done in the next 30 days before the ordinance becomes effective or unless one of the present establishments went out of business."

The ordinance also upped the ante for card club operators, raising the permit fee from $2,500 to $3,000 and the annual per table fee from $100 to $180. These increases are thought to have been brought about to offset the city's increased expenses for wartime defense activities.

2

BOOMTOWN

In the early hours of March 8, 1942, gunfire erupted inside the Twin Palms Club when veteran plainclothes LAPD officer Lee Bunch stumbled upon an armed robbery and shot it out with the gunmen—a gang of ex-convicts thought to be connected with a series of robberies throughout Los Angeles County.

Officer Bunch, forty-five years old and only a few weeks away from retirement, had been assigned the innocuous duty of the auto theft detail. Armed with a tip that he might find some tire thieves at the Twin Palms Club, Bunch found an after-hours 5:00 a.m. poker game in progress, sat down at the table and joined the game, posing as a card player.

The action was interrupted when three gunmen—Orville Horgan, Lyle Cecil Gilbert and John Lovelace—burst into the club. "This is a stickup!" the gunmen yelled as they began forcing the patrons face-first up against the wall. A getaway driver, Lyle's younger brother Max Gilbert, sat outside the club behind the wheel of an idling 1933 Oldsmobile on Redondo Beach Boulevard. While the patrons were being searched, the club's owner, H.N. Griffin, was found hiding in the washroom by Lyle Gilbert. After a brief scuffle, Gilbert struck Griffin over the head several times with the butt of his gun and robbed him of $317.

Pressed against the wall with the other patrons, Officer Bunch suddenly drew his hidden .38-caliber service revolver and fired, wounding Horgan and Gilbert before a return blast from Horgan's sawed-off shotgun caught Bunch squarely in the face, killing him instantly. Two other club

patrons were also wounded in the exchange of gunfire. Horgan, Lovelace and Gilbert escaped in their waiting getaway car. Two days later, Horgan died of his wounds. Gilbert and Lovelace were subsequently arrested and meted out death sentences. The driver, Max Gilbert, was given a life sentence for his part. While handing down the sentences, Judge William McKay warned of the necessity of stemming a resurgence of the gangster terrorism of the 1920s and praised Officer Bunch's courageous actions as the only thing that prevented a possible repetition of the St. Valentine's Day massacre.

Griffin was subsequently arrested by Police Chief Field and charged with illegally operating the club within forbidden hours (4:00 a.m. to 10:00 a.m.) and for having more than one card table in action. The club was only licensed for one poker table. After being tried and found guilty in the Gardena Police Court, Griffin paid a ten-dollar fine for the violation. However, Griffin's troubles with the Twin Palms Club were only just beginning.

In October 1942, Griffin appeared before the Gardena City Council in an unsuccessful attempt to have his license and permit reinstated for the club. They had been revoked by the council in late September over the fact that Griffin had pleaded guilty to violating the city's card club ordinance.

In a surprise turn of events, card club proponent Judge Carrell came out in support of Griffin's petition and offered financial assistance and mediation, reasoning with the council that Griffin should be issued a new permit for $1,500 instead of the $3,000 permit fee listed in the city's new ordinance. Griffin asked that, in addition to reinstating his license and permit, the city council authorize the club's relocation to Western Avenue along with seventeen additional table licenses for the new establishment. However, the city council unanimously refused to reinstate Griffin's license and permit, returning all of his submitted checks, including a $500 check offered by Judge Carrell.

The final straw for the Twin Palms Club was the police raid on a poker game held in the club over the Christmas weekend of 1942. Police arrested Fred Riggins, a friend of Griffin's, on charges of operating the game without a license. Riggins had been hosting his own fourteen-person private party in the establishment, now calling itself the Twin Palms Café. When questioned by police, Griffin, who was not present at the time of the raid, said that he had merely loaned the use of the building to Riggins and no fees were being collected from the poker game.

In the aftermath of the Twin Palms Club closure, the city forged ahead with a series of new fee hike proposals raising the cost of operating the clubs

by considerably increasing the cost of the annual license fees and transferring licenses to new establishments in Gardena.

During this period, Primm skillfully dodged a bullet upon receiving a visit from one of Los Angeles's most notorious citizens, gangster Mickey Cohen. In an interview with the author, Primm's former public relations executive Blaine Nicholson recalled Primm's account of the meeting:

> *Mickey Cohen came down* [to Gardena] *to have a meeting with Ernie Primm. And when Ernie met with him, Cohen said, "I want a piece of this action." Ernie said, "There's nothing here for you. These are legal card clubs, run by license in the city. And you couldn't do the things here that you do other places. And there's no money here. You know, you're not gambling against the house. These are fees. Every hour, some girls come around and pick up a few dollars." So he talked Mickey Cohen out of it, and Mickey left and never came back.*

In 1943, Primm moved up into the big league, buying a 25 percent interest in the Palace Club, one of the oldest casinos in the city of Reno, Nevada. Primm's experiences in Gardena would prove to be the foundation for all of his future endeavors and the perfect training ground from which to graduate to the high-stakes world of Reno. Primm's partners in the Palace Club were Baldy West, James Contratto, Joe and Vic Hall and Archie Snead Jr. The partners took out a ten-year lease on the club's property from John Petricciani. The partnership between Primm and Baldy West proved to be rocky at best, and in 1951, Primm sold his share of the club, leaving to pursue his dreams of owning his own Reno hotel and casino.

By the summer of 1944, Gardena was still home to only four card clubs: the Western Club (opened in August 1942), the Embassy Club (opened in January 1942), the Gardena Club and the Monterey Club (both opened in 1940). When Gardena's large population increases were made evident by the 1944 census, the pressure was on for the city to license more clubs. Judge Carrell, continuing to advocate for the card clubs and their financial contribution to Gardena, was one of the first to petition the city council on the strength of the latest city population total of 9,319.

The city, now presided over by Mayor James Rush—following the death of Mayor Bogart—increased the license fee for each table from $180 to $425 and voted to reject a joint petition from Judge Carrell and local businessman C.C. Dunbar over conservative fears that granting a new club license would throw open the gates to an unlimited number of card club requests. Police

Chief Field also supported the council's decision by making it known that the city's law enforcement resources could not be stretched to properly accommodate another club.

Dissatisfied with the city council's response, Judge Carrell circulated a petition and collected six hundred signatures in support of licensing new card clubs. Upon presenting his signatures, the judge took the extra measure of including a paragraph in his petition suggesting that if the council would go against the wishes of Gardena's citizens and deny the request for additional clubs that it should do away with the entire ordinance and revoke the licenses of the four existing clubs currently benefiting from the lack of competition.

By October, the issue had picked up so much steam that a counter petition was underway, with the collection of eight hundred signatures submitted to the city council in opposition of adding more card clubs. With the exception of giving permission for Primm's Monterey Club to relocate from Western Avenue to a new location at 14001 Vermont Avenue, the city council appeared in no mood to grant applications for new clubs. Licenses for card clubs remained limited, and up until March 1945, there were still only four card clubs operating in Gardena, with the Western Club having changed its name to the Normandie Club. In early March, the local Veterans of Foreign Wars post filed a card club license application to operate an establishment to be known as the Fortune Club at 15510 South Western Avenue. A second application for a card club license was also filed by the local American Legion, to operate the new Casino Club at 1813 Redondo Beach Boulevard. The application stated that revenue derived by the Legion from the new club would be used for worthy veterans' causes both then and in the postwar period.

The entitlement of gaming licenses being issued to veterans' organizations in the 1940s is best explained not by the laws of Gardena but by the admiration and respect of the American people for the soldiers, many of whom were still fighting at the time. After the worst war in history, no patriotic American citizen would have objected to any program that would financially benefit Uncle Sam's retired warriors. On the evening of March 19, the Gardena City Council voted to allow licenses for the two new card clubs, bringing the total number of card clubs in the city to six, the number of clubs that would remain the norm for many years.

The financial benefits from the two new clubs came quickly; in April, the City Treasurer's Office reported taking in $31,550 from the VFW's permit, inspection and thirty-table fee for the Fortune Club and an additional

Gardena, Monterey and Normandie Clubs thriving in the postwar years. *City of Gardena Archives.*

$23,050 from the American Legion for the operation of twenty-five tables at the Casino Club. However, for Gardena, more card clubs brought more trouble as well as more money.

Headlines concerning a series of violent incidents surrounding the clubs put a negative spin on the city's blossoming industry. In September, fifty-

three-year-old Harry Hartman, a retired LAPD officer now working as a doorman for the Embassy Club, was gunned down while trying to stop a holdup man who had just robbed the nearby Embassy Café and Cocktail Room. Newspaper reports detail how Robert Bettys, a former Merchant Marine, held up the Embassy Café cash register at midnight on a Sunday right before closing time. Harry Syde, the café manager, was counting out a total of $160 cash from the register when Bettys, who had been drinking in the café, pulled out a German Luger revolver and demanded the money. "This is a stickup. I'm not kidding," ordered Bettys. Syde handed over the drawer and let Bettys grab the cash.

Maxine DeChristina, a waitress from the Embassy Café, ran down Vermont toward the Embassy Club and found Hartman on the door. DeChristina frantically informed him of the holdup and asked him to call the police. Meanwhile, Bettys was making his way through the parking lot at the rear of the Embassy Club looking to steal a getaway car.

As the Gardena police arrived, they began searching the parking lot but were alerted to the front of the building by the sound of gunfire being exchanged between Bettys and Hartman. The three officers—Sergeant Roy Tracey, Frank Hodgson and Floyd Simmons—rounded the corner and opened fire, striking Bettys in the leg. As the smoke cleared, the officers found Bettys crouching on the sidewalk holding his smoking Luger and Hartman lying dead against a parked car in a pool of his own blood. Bettys later testified that for him it had been a "lost weekend" and he had no memory of going to the bar, much less robbing it. He was eventually convicted of assault with intent to commit murder and sentenced to ten years in San Quentin. The jury was unable to convict Bettys on the charge of murder, as it was deemed that Hartman had been killed by the crossfire between Bettys and the police.

Another unfortunate incident concerned the holdup robbery of a Normandie Club bookkeeper, Blanche Blum, at the Gardena Boulevard branch of Bank of America while she was waiting in line to deposit $6,172 in cash from the club. The bandit, a twenty-five-year-old ex-convict named Wendell Coffman who had recently been paroled from San Quentin, followed Blum from the club to the bank. Standing in line behind Blum, Coffman snatched the moneybag from the unsuspecting bookkeeper and made a run for it. "Stop that man! He took my money!" screamed Blum, running out into the busy street behind him.

Carl Ritzman, a twenty-nine-year-old Pacific Railroad switchman who had also been standing in line at the bank, tackled Coffman. The two men

began a violent struggle. Blum, about to jump into the fight to help Ritzman, was held back by another spectator who grabbed her by the arm, screaming, "Look out. He's got a gun!"

Ritzman succeeded in knocking the gun and moneybag out of Coffman's hands, but in the ensuing struggle, Coffman regained possession of the gun and fired a shot into Ritzman's face, killing him instantly. With more than one hundred onlookers watching along busy Gardena Boulevard, Coffman ran into a nearby service station and carjacked a hopped-up Ford Model A driven by two local teenage boys, forcing them to drive him away from the scene of the crime. The fleeing car happened to pass by the Gardena police station at high speed, just as Police Chief Field was taking a stolen car report from Mrs. Earl Lander. The chief decided to give chase.

Field briefly exchanged gunfire with Coffman while trailing the car to 124th Street and Avalon, where Coffman abandoned the Ford and ran into an eighty-acre eucalyptus grove near an oil refinery, escaping to a waiting getaway car, which turned out to be the car stolen earlier from Mrs. Lander, driven by Coffman's sixteen-year-old accomplice, Richard Burton.

After a nationwide search, in November 1945, Coffman was finally apprehended by fluke in Chicago after a violent protest over being evicted from his hotel room in order to make way for guests of the incoming American Legion convention. Fingerprints from what had begun as a routine investigation by Chicago police revealed his true identity. Coffman was promptly extradited to Los Angeles, found guilty of murder in Superior Court and given a life sentence.

Perhaps because of the number of clubs, now six—including the recent additions of the Fortune Club and the Casino Club—or because of negative publicity caused by their operation in the city of Gardena, a movement was building to oust the clubs. That November, a church delegation led by local ministers attended a city council meeting. The crowd of three hundred packed the council chambers and overflowed into the street outside while the Reverends S. Martin Eidsath, Gerald Stahly and W. Floyd Alexander addressed the council, urging them to act on an earlier proposal by Mayor Rush to repeal the city's card club ordinance.

Mayor Rush responded to the protest by informing the group of the difficulties involved with this request and pointing out how the city would have to raise taxes to offset the deficit that would be left behind. As attorney Sammy Rummel took to the stage and sparred with the reverends over what was best for the city, both sides invoked the will of the people, expressed by referendum, to support their views.

Councilman Adams Bolton argued that if the decision was given to the people in the form of a vote, the issue would be settled once and for all. The session closed with Councilman Potts proposing that the issue be put on the ballot for the April 1946 election. Plans to petition for an ordinance abolishing the card clubs were quickly announced by the local ministers, accompanied by a statement of reasons:

> *Gambling attracts a type of people that are not a benefit to the community. The home life and child life of our people is injured by the presence of people and businesses engaged in gambling or maintaining places of gambling. Gambling is not allowed in any other part of this state with the result that Gardena is the rendezvous for gambling for the entire state.*
>
> *Such statewide concentration of gambling in a community the size of Gardena destroys the public morals, which in turn drives out honest industry and business to the financial detriment of our people.*

On the last day of December 1945, a Sunday joint meeting of Protestant churches was held at the First Baptist Church under the auspices of the Gardena Ministerial Association and attended by approximately 150 people who listened to an outline of the proposed campaign and the reasons for it. It was at this meeting that a group calling itself the Committee Opposed to Gambling in Gardena was formed, headed by a number of local pastors, including Dr. Mounts, pastor of the Methodist church; Reverend Alexander, Baptist church pastor; Dr. Eidsath, Presbyterian pastor; Reverend J. Emory Ackerman, Lutheran pastor; and attorney John Loucks of Los Angeles.

Reverend Ackerman, a shy, mild-mannered former corporate accountant, informed the audience at length about the impending financial deficit that the city would need to make up in the absence of the card clubs. He described how the city would need $15,000 to balance the budget for the year, in addition to a healthy tax hike. He also suggested that the city's new Gardena Municipal Bus Lines, a venture started with the financial backing of the clubs that had restored much-needed public transportation after Pacific Electric Red Car service to the area was dismantled in 1940, could share a portion of its profits with the city, estimated to be in the range of $10,000 for the previous two years.

"You are going to see more money spent on this election than you have ever witnessed…to keep these card games going!" Attorney Loucks charged, working up the crowd. Reverend Alexander responded that if Gardena couldn't sustain itself without the tax revenue of the card clubs,

it should be disincorporated and returned to the control and operation of Los Angeles County.

Summarizing the case against the clubs, Dr. Eidsath mapped out the evils brought about by legalized gaming, charging, "There is a trinity of evil. I have never seen them separated—that is gambling, liquor and prostitution....Let one get hold and automatically it will bring the other two with it."

By early 1946, at the urging of local ministers and other anti-gambling residents, a referendum that would have outlawed poker in Gardena was well underway with an intensive campaign to obtain the signatures of one thousand anti–card club registered voters. At a Sunday night union meeting of the Protestant churches held at the First Baptist Church of Gardena, Dr. Mounts and Reverend Alexander preached to a crowd of one hundred about how Gardena had a choice between two futures: one of becoming a progressive city with a real business center or the alternative, a city just known as a place for gambling.

While it was only necessary to gain 400 signatures in order for the petition to make it to the April ballot, both the Committee Opposed to Gambling in Gardena and the Gardena Ministerial Association wanted to make a show of force. On February 4, over a month ahead of the deadline, a widely circulated petition bearing 739 signatures was filed with Lucille Randolph, the city clerk, who quickly determined 584 of the names were valid, registered Gardena voters. A spirited campaign followed, with the opposition headed by the Taxpayers Protective Association of Gardena boasting the slogan "Keep Taxes Low—Vote No." Both sides bombarded voters with campaign literature and door-to-door polling in the lead up to the election. The anti-gambling issue became so heated that it completely overshadowed the other items on the ballot.

Councilman Bolton, a prominent local realtor specializing in industrial realty and Gardena's chairman of finance, ordered the city auditor to determine exactly how much revenue the city was taking in from the clubs. Bolton explained that based on all the propaganda being generated by both sides of the campaign surrounding these figures, it was his job to make sure the public were not misled when making a decision at the polls.

The audit revealed that in four years and eight months of card club license fees and contributions to the city, Gardena had taken in $190,843.70. The overall revenue for the city during this same period was $671,334.71. A side note discovered during the audit process revealed that the Gardena Municipal Bus Line, connecting Gardena to downtown L.A. and other surrounding suburbs, was—on its Vermont and Western Avenue runs to and

from the card clubs—bringing in an average daily total of 515 passengers. This tally resulted in an estimate by the city that commuting card club patrons were earning the city's bus line as much as $1,500 in monthly fares.

A strong push to promote voter registration resulted in the number of registered voters climbing from 3,733 to 4,557 and, at the time, the heaviest vote recorded in Gardena's history, attracting long lines at the polls. Even the sale of alcoholic beverages was put on hold for Election Day. With excitement surrounding the election's outcome, the local hometown newspaper, the *Gardena Valley News*, stayed open late into the night, posting update bulletins outside its office as the final results trickled in from the city's five polling stations. Crowds gathered outside the newspaper office awaiting the updates, and the phones rang all night with inquiries from all over the country about the results.

With the pro–card club "No" and anti–card club "Yes" campaigns dominated by economic/taxation concerns versus religious/moral concerns, in the end, the "Yes" anti–card club measure failed with a vote of 1,097 to 1,522.

The city's first order of card club business in the aftermath of the election was to hike the license fees, the seventh such increase since the clubs began in 1936. With 175 tables now operating, newly elected mayor Adams Bolton seized the opportunity to raise table fees by $100 to $525. With this adjustment and the passage of additional ordinance resolutions, raising the number of tables allowed in each club from 30 to 35 and the inspection fee for relocating a club from $10 to $100, Mayor Bolton ensured that the city's coffers would be filled handsomely over the coming years.

The new mayor also helped raise the stakes for poker players by introducing an amendment changing the bet limit from $6 to $10. All of this was done in an attempt to lower the city's tax rate to $0.50 for every $100, but over objections, the tax rate was set firmly at $0.80 for every $100, one of the lowest in the state. Councilmen Rush and Platky feared that by lowering taxes further, the city would become even more beholden to the card clubs and argued vigorously that the city should maintain its own safe tax base margins independent of the club revenue.

With the exception of the death of former silent movie actor Walter James—a fatal heart attack—during a poker game at the Gardena Club, the post-election card club business of 1946 was tranquil. In a generous show of goodwill, the Normandie, Monterey, Embassy, Fortune and Gardena Clubs began making a series of donations gifting the city with nearly the entire $65,000 construction budget for Gardena's first Teenage Recreation Center.

Donations were made incrementally for approximately eighteen months on a pay-as-you-go basis through the building's completion in late 1948.

Ernie Primm's personal philanthropy in Gardena far exceeded the efforts of other club owners. Every year, during the holiday season, Primm's Monterey Club used an army of workers to distribute Christmas dinners to needy Gardena families. Hundreds of meals were prepared and distributed by five crews of Monterey Club workers who gave up their Christmas Day to see through the massive effort. The piping-hot dinners were served as full-course meals in big baskets containing generous servings of turkey, cranberry sauce, dressing, several kinds of vegetables, fruits, nuts, celery, olives and a salad—topped off with a mince pie and candies for the youngsters. The baskets were delivered to the families in unmarked trucks to avoid embarrassment. The Monterey Club was set up as a headquarters for the annual distribution, while the Gardena Valley Chamber of Commerce would assist by collecting names of the deserving families. Letters and names of needy families flooded in from all over the city.

Most requests were to help out families where the father was suffering from an illness or out of work and, in some cases, families struggling to support many children. On one such occasion, the Christmas dinner drive received a letter from a little girl, who wrote, "Dear Santa Claus: Will you

Christmas gift baskets for the needy being assembled by workers at the Monterey Club. *Blaine Nicholson.*

see that my grandmother gets a box for Christmas. She is in bed all the time. I want a baby doll."

Upon receipt of the letter, Frankie Martin commented to the press that while the Monterey Club had not gone into the "Santa Claus business," the little girl would be receiving her doll and both she and her grandmother would also be receiving a real holiday dinner.

The Christmas dinner drive was assisted by Gardena's welfare chairman, Mrs. William Mowatt, who took on the responsibility of confirming that all the dinner requests were bona fide. Mrs. Mowatt coincidentally had hosted the meeting that launched the anti-club letter-writing protest campaign during the spring of 1937. Evidently, over a decade since the opening of the Embassy Palace, she had experienced a change of heart or, like so many others in the community, had decided to embrace the benefits of being home to the card clubs.

However, for Gardena citizens, coexisting with card clubs often meant tolerating the clubs' notoriety. Gardena's sixth club, the Casino Club, was at the center of a lawsuit in November 1946. Beverly Hills businessmen Sol Gross, Ben Schubb and Louis Ketchell were suing Tony Cornero and seven of his associates for $50,000. The businessmen had invested $21,000 in what they thought was an interest in the Casino Club, with a portion of the money going toward improvements to the property. They were now contending that Cornero had never made any improvements to the club and their money was part of a $36,000 sum that federal government officials had impounded when they took over the *Lux*, also known as *SS Tango*—one of Cornero's offshore gambling ships—in a federal libel action. An injunction was requested to prevent Cornero and his associates from disposing of the funds if they ever got them back from the government.

In September 1947, Gardena's card clubs lost one of their biggest boosters when fifty-eight-year-old Judge Carrell died unexpectedly of coronary thrombosis at Torrance Memorial Hospital. A massive funeral service followed. Reverend Alexander officiated, and hundreds of mourners filled the First Baptist Church to capacity and lined the streets outside to pay their final respects. Floral tributes banked the heavy bronze casket, and a detail of California Highway Patrol motorcycle officers escorted the judge to his final resting place at Roosevelt Memorial Park cemetery.

For Primm, controversy erupted again in 1948 when he found himself in the crosshairs of the governor's Crime Commission over Attorney General Fred Howser's attempt to aid his application for a small loan broker's license. The Crime Commission immediately went to work investigating Primm's

property holdings upon discovering financial statements given with his application listing assets valued "in excess of $300,000."

The Crime Commission determined that such a license, in Primm's hands, would be used to aid what effectively boiled down to loan sharking practices in the eyes of the state. Howser defended Primm, asserting that in the decade since the Embassy Palace was closed down and branded a public nuisance, the entrepreneur had been "morally rehabilitated, and would conduct his business honestly and fairly."

In response, the Crime Commission painted a bleak picture of Gardena's card clubs. Revealing stereotypical attitudes toward women at the time, commissioners detailed how the clubs relied heavily on patronage from housewives who would lose small family fortunes during their afternoon games. Fearful of telling their husbands, they would become desperate and attempt to raise money by taking out loans against their personal possessions. Oftentimes, these women would drive themselves further into debt by frantically trying to recoup their initial losses at the poker tables.

Primm already held a real estate broker's license at the time Howser intervened, yet the small loan license was never granted, with an examiner from the California Division of Corporations concluding, "The commissioner cannot find that the financial responsibility, experience, character and general fitness of the applicant are such as to command the confidence of the community and to warrant belief that the business will be operated honestly, fairly and efficiently."

The concept of patrons being offered credit at the card clubs has evolved over the years. In the age before credit cards, the club's credit managers would use customers' bank statements to determine their average balance. Players would then be afforded 10 percent of their average bank balance in credit. The fact that customers were never extended more than 10 percent was a way of controlling people so they didn't go overboard and create impossible debts. However, once credit cards became the norm, players became completely responsible for themselves.

In early 1948, the American Legion made a request to relocate the struggling Casino Club from its home on the corner of Redondo Beach Boulevard and Western Avenue to a prime location at the southwest corner of Vermont and Rosecrans Avenues.

A letter from the American Legion to the city council declared, "For sometime past it has become increasingly apparent that the location…is not satisfactory and that a card club could not be profitably operated at that location."

This revelation was reinforced by the fact that in the period predating the Harbor Freeway, Vermont Avenue was the main thoroughfare for people coming south from Los Angeles into Gardena. By this rationale, clubs along Vermont would have been the first choice for most patrons. The Legion soon opted to close the Casino Club but continued paying the $1,200-per-month license fee while it found a new location.

The Vermont Avenue property that the Legion had its eye on belonged to the estate of the late Arthur Davies, a well-known Gardena realtor. Plans commissioned for a new $75,000 brick building by architect Donald Brode suggested its design would be modernistic, including a café and featuring a 60- by 80-foot main room along with smaller rooms in its 120- by 100-foot area.

Initially, the city council was not opposed to the relocation. However, the American Legion would have to go through the mandatory process of filing an application and erecting the building for approval by the city building inspector. The Legion urged the council to guarantee its approval in advance of any construction costs, but in return, the council advised that the new structure be built in such a fashion that it could be repurposed as another business in case the relocation failed. Confident the project would ultimately be approved, the Legion signed a twenty-year lease for the land.

Soon after, an injunction suit was filed in Los Angeles Superior Court by C.C. Dunbar, former operator of the Casino Club, against Legion commander George Liebsack and Hardy Lee, a former contractor originally from Nebraska, seeking $52,000 in damages for alleged interference in his contract with the Legion. The suit stemmed from the Legion's cancellation of its contract with Dunbar over allegations Dunbar allowed a third party to operate the club without the Legion's written consent. After tearing up its agreement with Dunbar, the Legion signed a new contract making Bow Herbert and Hardy Lee the Casino Club's new operators. This decision would ultimately drag the club into the clutches of the underworld.

Lee's attorney, Vincent Blumberg, told the press that although Lee was listed as the new building's owner, he actually represented "eastern interests" now known to be the Ver-Crans Corporation (an abbreviation of Vermont and Rosecrans, the intersection where the property resided). Blumberg declined to identify the names of the actual owners or state what their plans would be for the building.

Shortly after Dunbar's injunction suit was denied, Hardy Lee, who had been paying $1,200 a month for the Legion's license, announced the construction of a new ultramodern club on Vermont. But as the work

started, the city council began reviewing steps for a new card club ordinance more restrictive than anything in place up until this time. Proposed new provisions included that club permits and licenses be nontransferable between owners and locations and no new permits or licenses be issued for clubs at any location not already approved, with the exception of locations in the manufacturing and industrial zones to the south of the city.

The latter provision, if approved, would certainly kill the Legion's chances of opening its new card club on Vermont Avenue. With excavation already underway and a freshly issued building permit, the race was on to finish construction at 14305 South Vermont and receive city building inspector approval before the new ordinance could take effect. As an extra measure, the Legion threatened a recall of every city councilman who would vote for the new ordinance. The Legion viewed the proposed changes to the law as discriminatory, considering it was the only group currently relocating a club. Further threats from the Legion included that, if the move was denied, members would lobby for the ban of all card clubs in the city of Gardena. Legion member Eddie Fore, who had been prominent in securing the organization's card club license in 1945, led the charge along with former commander George Liebsack. However, when the council approved the new card club ordinance in December 1948, the Legion decided to rescind its threats and trust that the city would still treat the Casino Club's relocation fairly.

With the end of 1948 fast approaching and the new ordinance taking effect January 5, 1949, the feverish construction of Hardy Lee's building desperately neared completion with a double crew of workers putting in extra overtime seven days a week. But a building inspection in early January revealed that the project had missed its deadline. Despite further pleading by the Legion, the council would be powerless in granting the transfer until the city's building inspector could approve the structure.

The project would have been completely dead if not for the fact that by denying the Legion's request, the city would be turning away $13,500 in additional revenue from the nearly completed club. Another consideration for the city was the need for a new jail, for which the extra revenue would surely help cover the cost to the building fund. The council agreed to give its final decision on the matter, and in April 1949, it yielded to the American Legion's request and unanimously granted the transfer of the Casino Club license.

Almost as surprising as the council's reversal on its initial decision over the transfer was the fact that Councilman Rush, who had introduced the

prohibitive new ordinance, ultimately led the charge in granting the license transfer. It's possible that Rush and his fellow councilmembers folded under financial pressure. However, it's also noteworthy that Hardy Lee and the Ver-Crans Corporation had already begun the process of taking up legal proceedings that named the city, the mayor and four councilmen as defendants in a twelve-page complaint, replete with exhibits.

The newly minted Horseshoe Club hosted a grand opening on June 10, 1949, with the backing of the mysterious Ver-Crans Corporation and the use of Tony Cornero's old Casino Club license. The license had been transferred into these hands via the American Legion leasing it to Hardy Lee. Under the cover of Lee, who had lived in Gardena for over a decade, the Ver-Crans Corporation was making lease payments of $1,200 per month to the American Legion.

The club's main room accommodated thirty-five tables, the maximum number of tables allowed by the city ordinance. The *Gardena Valley News* described the club in lush detail:

> *Its dining room, papered with three and four leaf clovers, will seat 100 diners. Three huge horseshoes done in neon lights beckon Lady Luck by night. A parking lot, fully blacktopped, provides ample parking facilities for 250 cars, and an estimated 75 employees will keep the palatial establishment running smoothly.*
>
> *Interior decoration of the club is the work of the outstanding decorating firm of Aaron Schultz of Long Beach. The main playing room is done in full restful greens, gold, and chartreuse. The effect of spaciousness is heightened by the use of scenic paper on the rear wall above a dado. This depicts the Hudson river in subdued greens and browns. Drapes in both the card room and dining room are hand painted and were especially designed. In the card room the motif was taken from a horse blanket while horseshoes and four leaf clover motif have been employed in the dining room. Twenty-four artists were engaged for this hand work.*
>
> *Entrance halls have been dramatized by the use of unusual wall paper. One features Balinese dancers. The wall to wall carpeting is in subdued tones of green and tan, making a neutral background for the green of the playing tables and the scarlet upholstered chairs.*
>
> *A spacious ladies lounge is done in greens, chartreuse, and deep red with drapes in floral pattern. Chairs are upholstered in silk damask in shades of green and grey.*

In an effort to level the playing field for the smaller clubs, in early 1948, the VFW and American Legion proposed that the city limit the number of tables allowed in each club to thirty. At that time, the Fortune Club had thirty tables; the Casino Club had fourteen tables; the Embassy, Normandie and Monterey had thirty-five tables each; and the Gardena Club had twenty-eight tables. But the thirty-table limit change didn't take effect until the clubs settled on a gentlemen's agreement in the fall of 1949—after the opening and instant success of the Horseshoe Club threatened to take a healthy slice of the business. With heavy competition for patronage in the wake of the new club's arrival, extensive remodeling of all the other clubs was underway.

Cornero had successfully managed to pass his gaming license on to a group of individuals who under any real scrutiny would have failed the screening process. The Ver-Crans Corporation's principal shareholders consisted of Thomas W. Banks, brother-in-law of Hardy Lee and head of a Minneapolis crime family; Phillip "Flippy" Share, a criminal with ties to Chicago and Florida mobsters; Jack Davenport, a former burglar and brother-in-law of Willie Heeney, reputed to be the boss of Cicero, Illinois; J. Stanley Brown, a former prisoner at Alcatraz who was released in 1941; Harry Shepherd, Thomas Banks's bodyguard and a convict from Minnesota who had served nine years of a murder sentence; and Bow Herbert, a former salesman from Chicago, now living in Pasadena, who had no criminal record.

Local criminal Johnny Byrnes was also thought to have a 15 percent share in the Horseshoe Club, although he refused to identify himself as having anything more than an interest as a co-manager. Byrnes was known to have considerable ties to the city council through his close association with Charles Fred Kerr, an auto dealer, former bootlegger and prominent property owner, who was also rated as Gardena's wealthiest citizen. Byrnes's relationship with Kerr had been instrumental in bypassing the ordinance rules to facilitate the transfer of license from the old Casino Club. Because Byrnes and his associates had threatened to take the matter all the way up to the Supreme Court to make their case for the license transfer, it is thought that the city and other club operators decided to allow the transfer rather than risk another spotlight on the Gardena poker scene that could jeopardize its legality.

In an effort to conceal the identities of this large group of criminals, Hardy Lee appeared on the paperwork as the club's sole owner. The other names were listed as stockholders in the building that housed the club. At the time, Gardena card club owners enjoyed nearly total anonymity due to the city council shielding their identities from the public, classifying

the ownership lists as "confidential." The group of toughs took over the operation of the Horseshoe Club until the U.S. Senate Special Committee to Investigate Organized Crime in Interstate Commerce—popularly known as the Kefauver Committee because of its chairman, Senator Estes Kefauver—came into Gardena during the spring of 1951 to investigate the card clubs. The Kefauver Committee had begun a series of hearings in Los Angeles designed to explore the state of organized crime, part of a fact-finding exercise to obtain a nationwide picture of criminal activities. The group took a special interest in the workings of the Gardena poker clubs and subpoenaed Gardena city clerk Lucille Randolph and her records pertaining to the ownership of the clubs. According to the West Coast Kefauver hearings testimony of Charles Holleran, a recent transplant from Garrison, Minnesota, and the Horseshoe Club's manager, plans for the club had begun three years earlier, when Lee obtained financial backing from his brother-in-law, Thomas Banks.

Bow Herbert, a man who looked more like a banker than a card club owner, was originally from Beaver Dam, Wisconsin. His career had consisted of stints as a salesman, an agent-cashier for the U.S. government, a stage company manager and, during World War II, selling concessions to employees at war plants. After arriving in Southern California nearly broke in 1947, Herbert, with the help of a Chicago attorney, was able to raise enough capital to buy the Casino Club. "I was just a country boy in Gardena. Within a few weeks I bought the whole operation—or I thought." It turned out he had purchased an 18.5 percent interest for $43,000—only to discover that the club's license belonged to the American Legion.

Unfortunately for Herbert, the cast of the Ver-Crans Corporation took over the operation, exiling him to working in the club's kitchen. The Horseshoe Club became notorious for employing ex-convicts, who were reportedly offered jobs in return for buying an interest in the club. In reality, they never received an interest after making their payment, as confirmed by one such ex-con, Raymond "The Fox" Wagner, a cashier in the restaurant section, who had previously served fourteen years in Folsom Prison for kidnapping and involvement in the shooting of a Long Beach policeman.

With allegations from Los Angeles police chief William Parker of organized crime ties and the damning testimonials from the Kefauver hearings, a spotlight was put on the Horseshoe Club, forcing the City of Gardena to pull the license while a new probe of ownership was underway. All of Gardena's card club owners would now be up for review, with the city council making the list of ownership public. The city also passed a new

ordinance, raising the table fee from $525 to $700 and capping the number of clubs allowed in Gardena to a maximum of six, instead of basing it on the census results.

The council rescinded the decision to suspend the Horseshoe's license when attorneys for the American Legion and Hardy Lee presented proof that both the stockholders and Ver-Crans Corporation had been purged of all the undesirables listed in Chief Parker's report. Attorney D.A. Boone's testimony showed that, in actuality, many of the men listed by Parker had never held an interest in the Horseshoe Club, with the exception of Harry Shepherd, who had been convicted of third-degree murder for his part in a Minnesota car crash in which a passenger died. Meanwhile, the Ver-Crans Corporation sold the Horseshoe Club to Hardy Lee's wife, Minnie.

Herbert eventually bought out the Lees' interest in the Horseshoe Club and became the sole owner in late 1951. He also entered into a contract with the Ver-Crans Corporation to purchase the building and ground leases. This extroverted personality would years later be known for handing out a booklet to the clubs' customers telling of his humble beginnings on a dairy farm in Wisconsin.

The license for the Fortune Club was suspended in the summer of 1949. It had only been in operation for a few years before closing its doors. Signs of trouble started in July 1949, when the city council discovered that the club was advertising itself on the radio—a breach of tradition, if not law. Sam Kronberger, public relations chairman for the VFW post, told the council that the VFW did not want to jeopardize its license and that the organization had contacted the club's operators, requesting that they cease all advertising for the club. Nevertheless, the Fortune Club closed down in late August over management problems, reopening briefly before the city revoked the club's license and closed it down again on December 9, after Police Chief Field reported that the operators transferred ownership without first applying through the city. The club reopened the next day—under federal injunction—after complaints by the club's new operators, one of them an African American businessman named Clarence Moore, that the forced closing was a racist response to their mostly black clientele. The new operators had started advertising extensively in black publications in an attempt to attract the untapped local African American community. By mid-December, a U.S. District Court judge ruled that there was no racial issue involved in closing the club and the city was within its rights to suspend its license. Soon after, the city reinstated the club's license when Councilman Potts introduced the resolution that the club's violation of the ordinance had

been technical and not willful. But when attendance dwindled to fewer than a dozen players, the Fortune Club was closed again by its management.

The summer of 1949 saw a slew of anti-poker hysteria headlines plastered across the pages of L.A. newspapers, including stories about a poker-obsessed gambling grandma cashing bad checks to play and a young mother forced to take a sanity test after her infant child starved to death while she played cards in the Gardena poker parlors.

But the story that gained the most notoriety that year was the grisly murder of a forty-four-year-old North Long Beach surgeon, Dr. Donald Buge, in a desolate area just north of Gardena known as Athens on the Hill.

The body, sprawled facedown beneath an oak tree, was horribly battered; Buge's teeth had been knocked out, his nose smashed and splintered and his forehead was marked with a series of deep cuts, perhaps left by a heavy ring worn by the assailant—injuries so extreme that they left him unrecognizable. An autopsy would later reveal the unconscious doctor choked to death on his own blood.

Buge and his wife, Violet, had set out earlier that night to enjoy a midweek evening of poker at the Normandie Club. The handsome doctor was known to carry a large roll of cash for such occasions. When the couple decided to split up for a few hours, Buge left Violet to play cards while he headed across Western Avenue to the Colony Club, a popular burlesque club featuring cancan girls and acts by performers like Lili St. Cyr and Billie Bird. While watching the show, he struck up a conversation with a young Compton couple, Ted and Joyce Gardner. Ted was a local carpenter, a wiry, slender gambler. His wife, Joyce, was described as a sexy redhead with an upturned nose and freckles. Ted suggested the threesome drive up Vermont Avenue to Oliveri's Café in south Los Angeles to meet his friend Ralph "Blackie" Schwamb, a former pitcher for the St. Louis Browns. Schwamb had fallen on hard times, and Ted Gardner viewed Buge as a soft target flush with cash. After drinks at Oliveri's Café, the Gardners and Schwamb agreed to drive the doctor back to the Normandie Club; but on a desolate stretch of Vermont Avenue, they beat him to death, stealing fifty-three dollars in cash found in his pockets.

When detectives from the 77th Street Station interviewed the slain doctor's widow outside the Normandie Club, a squad of the club's bouncers—concerned about potential negative publicity—chased off a press photographer from the *Long Beach Independent*. The photographer was able to flash one photo of Violet Buge speaking with detectives before he was rousted. Shielding his camera, the photographer jumped into his car

and sped away—eluding the Normandie Club bouncers chasing him—and published his photo on the front page of the paper.

Two days later, with information cobbled together from employees at the Colony Club and then later the confession of Joyce Gardner, the three killers were arrested. Ted Gardner and Schwamb were both given life sentences. Schwamb resumed his baseball career behind bars and only served ten years of his sentence.

In addition to the criminal mayhem of the late 1940s, the lives of some of Gardena's biggest personalities in the gaming scene began to unravel. Josephine Primm sued Ernie for divorce in 1949 on the grounds of infidelity, citing film starlet Georgia Pelham, mother of the singer/actress Cher, as co-respondent. Ernie filed a cross complaint charging Josephine with cruelty when he had been sick two years earlier. Josephine took custody of the Primms' five children and was awarded—in addition to alimony and personal property—half of his interests in the Monterey Club and Reno's Palace Club.

As the holiday season of 1950 approached, forty-five-year-old Marvin Nischan, the colorful former manager of the Normandie Club and personal representative of Los Angeles attorney Charles Cradick, owner of the Gardena Club, became completely despondent over his financial affairs. After returning to his home in Inglewood from the club early one morning, Marvin walked outside to his parked car and put a .38-caliber revolver to his head. A single shot rang out, and Marvin's terrified wife ran outside to find his body slumped over the steering wheel. But this would only be the first violent death of someone connected to the Gardena card clubs during the remaining months of 1950.

On December 11, 1950, at approximately 1:30 a.m., the suave and wealthy courtroom lawyer Sammy Rummel arrived home, pulling his tan Cadillac into the garage of his $50,000 Spanish colonial mansion, located in Laurel Canyon high up above what is now West Hollywood and the Sunset Strip. When the forty-four-year-old Rummel walked up a set of outdoor steps leading to the front door, he was silhouetted by the home's automatic floodlight security system. An assassin, hidden in a tree on the wooded grounds surrounding the property, blasted him from behind using an Italian double-barrel 12-gauge sawed-off shotgun, which was left behind at the scene. The autopsy revealed that Rummel died of a hemorrhage from gunshot wounds to the head and neck—indicating that his gruesome death would not have been instantaneous. Police Chief Parker vowed to solve the murder case "if it takes every man on the force,"

but he was unable to identify the assassin or prove the involvement of any Rummel associates. The murder soon became another unsolved mystery in the annals of the LAPD.

Detectives working on the Rummel murder case quickly went to work questioning Ernie Primm and Rummel's law partner, Vernon Ferguson, in search of a motive for the killing. At the time of his murder, Rummel held a 15 percent stake in the Monterey Club. Rummel's share of the business had been earned in trade during his extensive legal services in 1941, beginning with helping to lift the injunction against the club issued by Judge Wilson that spring. While the Monterey Club was closed by the court order, Primm had signed a deal with Rummel in June 1941, agreeing to pay him 35 percent of the card club's net profits if Rummel succeeded in lifting the injunction. A year later, their contract was amended, giving Rummel instead $250 a month and 10 percent of the profits. A final amendment to their agreement was signed in June 1943, upping Rummel's share to 15 percent. Primm later revised the club's partnership agreement in August 1948, assigning the club's shares as follows: Ernie Primm, 65 percent; Frankie Martin, 10 percent; Russ Miller, 10 percent; and Sammy Rummel, 15 percent.

Rummel's widow, Norma, sued Primm in September 1951, demanding $40,000 on behalf of the slain lawyer's estate and an accounting of the Monterey Club's profits. The suit was eventually settled in the summer of 1953, when Primm agreed to a compromise, paying Rummel's estate a $44,230 settlement in return for Norma dropping her claims. Claims continued for years after the lawyer's death, but the courts ruled in Primm's favor.

Rummel was murdered on the eve of a grand jury investigation hearing into the Guarantee Finance Corporation bookmaking and pay-off program, possibly the largest illegal gambling operation of its kind in 1940s Southern California, with interests extending south of the border into Mexico. According to former captain Al Guasti's Kefauver hearings testimony, Rummel knew the names of prospective witnesses who would testify at the grand jury hearing and shared information with Guasti and Captain Carl Pearson (head of the vice squad) for some form of mutual benefit. Rummel himself was scheduled to testify about a conspiracy that existed between the county sheriffs and the Guarantee Finance Corporation.

Two days before his murder, Rummel was visited at his office by Pearson and Sergeant Lawrence Schaffer, who brought county records of the Guarantee Finance Corporation affair with them. Rummel's connections with the L.A. underworld and his stakes in various gaming operations would

have acquainted him with the Guarantee Finance Corporation's $108,000 "juice" payoff fund used to grease the wheels of law enforcement officials who would otherwise be cracking down on gambling interests.

One likely motive for his murder is that Rummel might have threatened to expose sensitive information about the Guarantee case to the grand jury. The head of the vice squad going over his files with the lawyer who would be representing the defendants was incriminating in and of itself. The idea that Rummel was fixing up something with these officers—or threatening to blow the lid off—could have led to him being killed.

During the mid-January 1951 hearings, Los Angeles police chief Parker alluded to his theory that Rummel's killing was somehow connected to the Gardena card clubs. When interviewed about attorney Charles Cradick's gambling interests in Gardena, Parker stated that Cradick was known to have at one time owned 40 percent of the Normandie Club but was later forced out of the club and made to accept $1,000 and 1 percent of his interest. Sammy Rummel had then assumed his interest in the club. Parker went on to explain how Marvin Nischan had also been forced out of the Normandie Club at the same time and committed suicide shortly afterward.

Years later, Chief Parker was misquoted by the press as having remarked at a Los Angeles City Council meeting that Gardena was a city infiltrated by the Minneapolis mob. Parker cleared up any confusion over what he had actually said by praising the Gardena City Council for the speedy action it took in evicting the criminals behind the Horseshoe Club after their presence was revealed by a police investigation sparked by the murder of Sammy Rummel.

In the wake of the West Coast Kefauver hearings, a legislative bill (No. 3377) seeking to outlaw commercial draw poker threatened the existence of the Gardena card clubs. Assemblyman Herbert Klocksiem, a Republican from Long Beach, introduced the bill with its focus aimed directly at Gardena. Governor Earl Warren was quick to endorse the bill, making a case that Gardena's card clubs were responsible for some of the worst rackets in the state. "I've talked to law enforcement officers in Southern California, and they tell me that poker parlors are attracting hoodlums from all parts of the country and creating a very serious problem," Warren informed the press. The governor also backed the popular belief among law enforcement that the "fight over the spoils of those gambling joints in Gardena was the cause of the assassination of Attorney Sam Rummel." However, when the bill went before the Committee of Boards and Commissions in mid-April, it failed to receive a favorable vote, referring

the issue to the Interim Board and essentially shelving it until mid-May, when the measure was killed by a vote of 8–2 by the Senate Governmental Efficiency Committee, allowing the Gardena card clubs to continue operating but adding to the pressures on their owners.

It is not surprising, then, that after his divorce and with the increasing pressure of legal challenges, in 1951, Primm purchased the four-hundred-acre site at the California-Nevada border that would go on to become known as Primm, Nevada. Years later, Primm was deeded an additional four hundred acres by the federal government. The original land was purchased for $12,000 from the estate of Peter "Whiskey Pete" MacIntyre, who died in 1933.

Up until his death, MacIntyre, a maverick Texan moonshiner, operated the dusty outpost on the road to Las Vegas as a two-pump gas station. Legend has it that MacIntyre was buried standing holding a bottle of bootleg so he could keep watch over the area. During Prohibition, the road running through was just a two-lane blacktop. Drivers coming from California or Las Vegas would stop to buy gas and a little moonshine before hitting the road again. Upon Sammy Rummel's death, there were press rumors suggesting the lawyer had considered opening a $750,000 Nevada casino with a Gardena operator (who would have of course been Ernie Primm).

The wall of Primm's Gardena office was adorned with an artist's rendition of the desert at the California-Nevada border, and he would tell anyone inquisitive enough to ask that one day there was going to be a casino out there—but nobody believed him. For most people at the time, the idea of building a casino in the middle of nowhere was an absurd pipe dream. It was ironic that Primm, who was known by close associates to be colorblind, had more vision than anyone else connected to the world of the Gardena card clubs.

In the summer of 1951, Primm leased a property in downtown Reno, Nevada, on the west side of Virginia Street called the Golden Gate Club, an area that was legally off-limits to gaming interests. During this time, Reno's casinos were confined by the city's zoning laws to operate along the east side of Virginia Street. Primm began the process of evicting his new tenants—a coffee shop, jewelers and some residential apartments—a process that would eventually result in the expansion of Reno's casino district boundaries. But when Primm applied for his Reno gaming licenses, requesting thirty slot machines, two roulette games, two craps games and four blackjack tables, the council immediately denied him, due to the Golden Gate Palace's location outside the perimeter of approved zoning.

Over the next four years, Reno's city council denied Primm's licensing requests numerous times, resulting in a repeat of the early Gardena days, with Primm taking his fight to the District Court and Nevada Supreme Court. Primm lost both times. During this period, he operated the property as the Primadonna Restaurant. It wasn't until 1955, when a local election changed the makeup of the city council, that Primm was finally granted his Reno gaming license. On July 1, 1955, the property reopened to a small crowd of summer gamblers as the Primadonna, eventually becoming a year-round operation, expanding its facilities and gaming offerings.

By the early 1960s, after winning a political battle against Reno's mayor, Bud Baker, the Reno City Council had agreed to expand the gambling zone again, allowing Primm to build out an extension to the rear of the Primadonna on Sierra Street, parallel to Virginia. Primm and his public relations ally Blaine Nicholson created campaign material for a group called the Reno Tourist Growth and Development Committee, circulating petitions calling for rezoning and gambling expansion on Sierra Street. When they collected ten thousand signatures in support of expansion, the city council gave way.

Primm celebrated by adding a fancy new theater-restaurant featuring the *Paree, Ooo, La La!* adult revue show. The popular show, which featured a host of lavishly costumed showgirls, was a hit and played to full houses. The adults-only revue offered three shows nightly at 10:00 p.m., midnight and 2:00 a.m. The following summer, Primm adorned the casino's marquee with five towering showgirl statues.

Eventually, Primm turned downtown Reno into his own personal Monopoly board, extending his real estate holdings by buying up blocks of neighboring properties, including the old Sears, Roebuck and Company building and the Pickett Hotel, making him the single largest owner of contiguous property in downtown Reno.

Not all club owners had Primm's touch. After a series of attempts, beginning in the mid-1940s, Gardena's Fortune Club had failed to live up to its name, and in May 1950, Joe Hall and some partners took over the struggling club, rechristening it the Western Club—in an attempt to change its image. But the venture remained unprofitable, and by the end of August, the club was notifying workers to collect their final paychecks.

The Western Club reopened with little fanfare in February 1951 under the short-lived management of Edward A. Syracuse and building owner Charles Fred Kerr. By August, the club had changed hands again, reopening this time under the management of Los Angeles businessman Abe Benjamin

A High-stakes History

Showgirl statues under construction at the Primadonna Casino in Reno. *Blaine Nicholson.*

and his associate Max Gold, former manager of Billy Gray's Hollywood comedy club, the Band Box. The club was redecorated and refurbished for its new opening, but just over a month later, fifty-year-old Kerr suffered a fatal heart attack at his Newport Beach home on Lido Isle.

After the death of Kerr, who had been a 10 percent partner and also the owner of the Embassy Club license, the Western Club underwent more

struggles, and ownership was transferred to L.M. Hoffman, a Los Angeles jeweler, with management handled by Benny Miller and Lou Underwood. The year 1952 began with the announcement that the club would once again reopen, with twenty tables, the minimum number allowed under the new ordinance. Fees for fifteen tables were paid up through April 19, with the other five paid through May 24. The club was refurbished once again and featured an entirely new staff, but the new owners quickly overextended themselves, falling behind on payments to the VFW for use of its gaming license. Hoffman filed for bankruptcy and even defaulted on payments to the club's staff.

On April 18, 1952, with only one day remaining on the countdown to renew the Western Club's expiring license for fifteen of its tables, Primm stepped in at the last minute and paid the $10,500 owed to the city, effectively rescuing the club's license. With the Western Club's license in hand, Primm immediately shut it down and went to work on building a new club next door to his plush Monterey Club on Vermont Avenue. The new venue would be called the Rainbow Club and proved itself to be a pot of gold for the next two decades, opening to the public on April 9, 1953.

Primadonna Casino advertisement. *Blaine Nicholson*.

The Monterey Club's dining room manager, a lifelong restaurateur named Emil Schmidt, oversaw the Western Club's transformation into the Western Café, a first-class remodeled dining hall with private rooms, specializing in large-scale banquets and parties, with a popular fried chicken dinner for $1.75.

Joe Hall, who had formerly held an interest in the Western Club, took over the license for the Normandie Club in April 1952. A newspaper article about the Gardena card club owners published in 1954 listed, among others, Russ Miller, Joe Hall, Bernard Van Der Steen and Norma Rummel as owners of the Normandie Club.

A High-stakes History

Bernard Van Der Steen was a wealthy businessman from Beverly Hills who was attributed with giving the Normandie its French antique theme. As an avid collector of European antiques, Van Der Steen was responsible for importing much of the club's furniture, red flocked wallpaper and decorations. These imports included a set of antique French stained-glass windows bearing the Normandie's fleur-de-lis crest. The window panels were later transplanted to the Normandie's final location on Rosecrans Boulevard as relics of the original club. Steve Miller recalled having the windows appraised at the time of the club's relocation in 1980. At that time, they were valued at approximately $20,000.

Similarly, Joe Hall was a very practical businessman who had come to Gardena from New York via Las Vegas. Hall had also previously owned a carpet store in the neighboring city of Hawthorne, earning himself the moniker "The Rug Merchant" among his card club partners. Hall, who was known to be a successful businessman and a stylish character, owned homes in Century City and Palm Springs. He was also an avid card player, remembered by many for his tailored shirts with monogrammed sleeves. Hall is also remembered for how much he enjoyed spending time with employees in the Normandie's kitchen, where they prepared his favorite lamb dishes.

The son of a butcher, Russ Miller was born in Kansas City, Missouri, in 1907. He was seven years old when his family finally arrived in Los Angeles. Miller became a partner in the Normandie Club in 1947. As a passionate follower of horse racing who never missed opening day at Santa Anita, the Miller family patriarch passed his love of "betting the horses" down to his sons. There was always a pen and paper kept next to the radio on the Millers' breakfast table, and Russ taught all of his sons how to record the results of horse races, tracking all the stats and who won Win, Place and Show. Lee Miller took his father's love of horse racing to another level, often attending practices, watching warmups and timing the horses. He later bought his first house with winnings from a racetrack.

A gentlemen's agreement between the Gardena club owners during the summer of 1952 prompted the removal

Russ Miller. *Miller family archive.*

of the new giant neon signage that had started to dot the city's landscape. The signs had come under fire in the community for their bold garishness, and as a result, the Monterey Club removed an outdoor neon sign depicting a group of poker players from its north-facing wall. The sign had employed colorful flashing animation and drew wide criticism. Even the Normandie Club had to rethink the size of its signage as part of that club's remodeling. This was an example of how the clubs would at times work together to stave off unnecessary backlash from the citizenry. An ordinance soon followed, limiting each of the clubs to one tasteful main sign featuring the name of the club in letters not more than three feet in height. The signs were also prohibited from containing any pictures or emblems.

In addition to the sign ordinance, the city decided to raise the club fees once again, this time creating a three-tiered system with fees based on three bracketed levels of monthly income. Clubs grossing under $20,000 would pay the regular $700 per table annual fee; clubs grossing between $20,000 and $55,000 would pay an additional $500 per month; and clubs grossing over $55,000 would pay an additional $750, or a total maximum of $1,250 per month. It was at this time that Primm was laying the foundation for a new property on the immediate north side of his Monterey Club: the $300,000 Rivera Restaurant. Designed by prominent Glendale architect Frank W. Green, the futuristic edifice featuring low sweeping lines and lots of glass was scheduled for completion in March 1953.

3

WILD CARD

Harry Klassman arrived on the scene in early 1953, and with a group of Los Angeles businessmen, he purchased the Embassy Club license and its equipment from Archie Sneed Jr. The Embassy's license had recently been transferred to Sneed from the estate of Charles Fred Kerr. Klassman would be the club's main proprietor, leasing the venue from his business partners. His previous business experience had been in running the Kaye Restaurant and Supply Company and the Century Equipment and Supply Company in Los Angeles.

Klassman promptly went to work on enlarging the Embassy Club, commissioning the services of Los Angeles architects Simpson Brothers for an extension on the south side of the property along Vermont Avenue and the construction of an imposing new entrance off the parking lot. The club's dining room and main playing area were enlarged, along with the additions of a new kitchen, a television theater and the redecoration of both the interior and exterior. The upgrade project was estimated to have cost $100,000.

Meanwhile, Primm was making big moves of his own, having the city council agree to transfer the VFW license from the Western Club over to his new property neighboring the Monterey Club, now being called the Rainbow Café. Frankie Martin and George Townsend were listed as co-owners.

The Rainbow's expansive card room featured thirty-five tables and was shaped like a three-leaf clover. A rainbow-shaped lunch counter and menu covers featuring rainbows played on the club's pot of gold motif. Soft shades

Harry Klassman, owner of the Embassy Club. *Blaine Nicholson*.

of coral, green and gold were used to decorate the sound-deadening wall coverings. Specially designed carpeting featured rainbows and pots of gold woven into the pattern. With windows that curved outward and exterior brick walls that acted as a series of curves, there was hardly a straight line in the building.

The property opened as the Rainbow Club on the evening of Thursday, April 9, 1953, to an immediate full house of patrons declaring it more glamorous than many of the stylish clubs of Reno or Las Vegas. At the time, the north property line of the Rainbow Club was also the northern boundary of the city of Gardena. The *Gardena Valley News* described the Rainbow's design:

> *The dining room separated from the clover-leaf shaped playing room with a partition of amber glass is particularly attractive. A myriad of colors have been used in the asphalt tile floor. Upholstery of the tete-a-tete lounges and chairs is in varied colored leather, dishes are vari-hued and unique*

A High-stakes History

ceiling lights resembling a cluster of bright colored balloons gives the café an atmosphere of gayety without a discordant note.

Martin had remained Primm's main partner going into the new club. In making the move, Martin disposed of all his interests in the Monterey Club, leaving principal control in the hands of Clarence Goodwin, with Primm retaining a limited partnership. The affluent playboy and high roller who hailed from Northern California was known to be a huge fan of horse racing and owned a string of horses. Martin's big contribution to the operation of the Rainbow Club was keeping the so-called Big Game going by sitting at the high-stakes table and playing all day. One telling aside about Martin

Rainbow Club parking lot sign. *City of Gardena Archives.*

Rainbow Club gaming floor. *City of Gardena Archives.*

and Primm's relationship was that Primm—who was conservative about flaunting his wealth in front of the customers—was always embarrassed when Martin would show up to the club in his Rolls-Royce.

The cigarette smoke–filled card clubs attracted people from all over Los Angeles County, but most of the Gardena card club patrons, many of whom were Jewish, came from the wealthier enclaves of West Los Angeles and Beverly Hills. It was well known that Gardena's citizens mainly patronized the card clubs for their great restaurants with low prices. Each club had its own specific type of clientele. For instance, the Gardena Club, which in 1950 had relocated a half mile south of its original location at 14808 South Western Avenue to Western Avenue and 154th Place, catered mostly to senior citizens. Comparatively, the Rainbow Club, in its earlier years, attracted the high rollers. Years later, the Horseshoe Club became home to the high roller crowd.

In the summer of 1953, a card club war began in Gardena with a warning of disciplinary action from the city council cautioning the club owners to come to a gentlemen's agreement over their various mounting

A High-stakes History

Left: *Niteout* dining magazine cover featuring the Monterey Club restaurant. *Blaine Nicholson.*

Right: *Suicide King.* Rainbow and Monterey Restaurants ad. *Blaine Nicholson.*

feuds. Accusations were flying between the clubs over illegal chauffeuring of patrons to and from their homes—a violation of the city ordinance that allowed only the Gardena Yellow Cab company and Gardena Municipal bus lines to provide card club transportation services.

Those close to the clubs' inner circles knew that the feuding stemmed from the fact that there wasn't enough business to support all six clubs. It was widely felt in the community that the club owners had missed a good opportunity to suspend the Western Club's license by splitting the dues among themselves and reaping the rewards of the disenfranchised customer pool.

Rumblings from the two smaller clubs—the Embassy and Normandie—indicated that the four other venues were attracting the majority of customers, leaving them at times with empty tables. The

group volunteered the suggestion of an alternative system that they would try out under a gentlemen's agreement to level the playing field, using the following rules: (1) all clubs be closed on Sundays; (2) clubs be limited to thirty tables each; (3) clubs cease transporting customers; and (4) clubs open at noon instead of 10:00 a.m.

The VFW opposed the reduction of tables because its deal with the Rainbow Club contained a clause that if the table count was ever reduced, the license fee to the VFW would also be cut. Even ministers from the area had never explored the idea of a Sunday closing on any moral grounds. Under this agreement, the city would charge the same fees on thirty tables that they would have for thirty-five tables, effectively raising fees from $700 to $820, so as not to reduce the city's share of revenue. But when the club owners failed to agree to these new terms, hurling accusations at one another in a council meeting about who could or couldn't really keep a gentlemen's agreement, the city stepped in and laid down the law, passing ordinance No. 308 (popularly known as the Shelby Ordinance after its author, councilman Robert Shelby) by a 3–2 vote.

The Shelby Ordinance increased the city's annual share of table fees by $43,000, raising the table fee to

Best Deal in Town! Ad for dinner specials at the Rainbow and Monterey Restaurants. *Blaine Nicholson.*

$1,000 and capping the maximum number of tables allowed for each club at thirty. The passage of the ordinance not only divided the card clubs into camps but also split the opinion of the city council, with councilmen Adams Bolton and Robert Shelby at odds over the fairness of such a resolution.

Bolton argued in favor of the larger clubs, calling the ordinance unconstitutional for only being beneficial to the minority of two small club owners. The larger clubs contended that they had been unsuccessful in solving the situation among themselves because the Embassy and Normandie refused to come to the bargaining table.

A new closing schedule suggested by the clubs via a gentlemen's agreement proposed that the Embassy and Normandie be closed on Sundays, the Rainbow and Gardena close on Mondays and the Horseshoe and Monterey close on Tuesdays. This staggered closing day agreement would remain in effect for the foreseeable future.

When Bolton proposed a revised version of the ordinance that would have all the clubs closed on Sunday, retaining the thirty-table maximum and the new $1,000 table fee, it was quickly shot down, as Mayor Rush wanted to hold out for a more inclusive ordinance that would incorporate the measure of mandatory fingerprinting for club owners and their employees.

It was finally decided that the controversial issue of a mandatory Sunday closing would be put to the voters on the April 1954 ballot. The issue of closing the clubs at 2:00 a.m. instead of their current 4:00 a.m. also came to the forefront after Mayor Rush suggested "it will sit better up in Sacramento," indicating that the California state legislators were keeping a watchful eye on the workings of the card clubs.

The most vocal objector to the new closing time was August Chopp, owner of the Gardena Yellow Cab company, who argued that he didn't have enough cars and drivers to accommodate a 2:00 a.m. rush on taxi service. Chopp insisted that wildcatters would become rampant—picking up the overflow of customers—and there were already forty-six wildcatters operating in Gardena against the law. "If they continue in business and the clubs close at 2:00 a.m., I don't think I'll last very long," Chopp pleaded. But on March 15, 1954, the new ordinance passed with a unanimous council vote, including provisions for a new 2:00 a.m. closing time, the new thirty-table maximum and a uniform Sunday closing day for all the clubs—effective April 18.

Another strong challenge to the card clubs came that spring when thirteen churches decided to join forces and form the Civic Improvement Committee of Gardena. The head of the group was Reverend Karl

Oelschlager, pastor of the Park View Lutheran Church, located on Crenshaw Boulevard in county territory outside of Gardena's city limits. But three local businessmen—Roy Bain, Roy Harbold and Bob King—also spearheaded a campaign running on the issue as the "three anti-gambling candidates," branding themselves as a collective ticket in an attempt to be elected to city council. Their plan was to get a referendum on the April 13 ballot that would ban the card clubs.

The group managed to get their cause on the ballot and actively campaigned to drum up support, distributing two issues of anti–poker club pamphlets as handouts on the streets and door-to-door by volunteers in residential districts. In the week leading up to the vote, competing sound trucks cruised through the streets of Gardena, telling the citizens which way to vote accompanied by an undercurrent of musical jingles. Meanwhile, armies of churchgoers marched down Vermont Avenue and formed groups outside the entrances to the clubs on a Sunday to sing hymns and persuade patrons not to enter the establishments.

Ultimately, the measure was narrowly defeated in a close vote of 4,531 to 3,721, with the church group's top man, Roy Bain, finishing a poor sixth in the city councilman race and his partners, Roy Harbold and Bob King, coming in seventh and eighth, respectively.

With the wildcat hauling practice still prevalent at Gardena's six card clubs, a feud had sparked between the Gardena Yellow Cab company and the clubs for allowing this infringement to take place. Employees of the Gardena Yellow Cab company were charging that these "haulers" (unauthorized or unlicensed common carriers) were actually being employed by some card clubs and deliberately cutting into their revenue.

Taxi drivers from the Gardena Yellow Cab company picketed the clubs with placards bearing inscriptions such as "Give Us a Living Wage." The Rainbow Club struck back at the picketers and filed a suit against the company's owners, August and Robert Chopp, along with one hundred John Does, asking for a permanent injunction against this kind of picketing as well as damages for $50,000. Finally, the city intervened, notifying all the clubs by letter that they would have to comply with the "strict provisions with reference to transportation to and from the locations permitted and licensed under said ordinance." Gardena's Police Chief Field made several arrests and fined some of the gypsy cab operators, but it was never proven that the card clubs had any direct involvement in the scheme.

The Gardena Yellow Cab company soon retaliated against the Rainbow Club, filing a suit of its own, alleging huge losses from the lost business. The

suit amounted to $45,000 in damages from "unfair competition," $25,000 in punitive damages and a demand for $5,000, which the Rainbow had previously agreed to pay for cab company insurance. In addition, the suit asked for $100 per week for a twenty-three-week term for "group loading service," which the Rainbow Club had declined to pay after the picketing episode. Ultimately, the city decided to drop the "anti-hauling" sections from its card club law, relieving itself from the difficult duty of having to enforce the code.

Things had not improved for Klassman since the passage of the city's new ordinance. The Embassy Club's courier had been robbed at gunpoint for $5,905 on his way to make a deposit at Bank of America, and the city's new council members—led by councilman Robert Finch—had made amendments to the ordinance, restoring the maximum number of tables to thirty-five, 4:00 a.m. closing times and Sunday hours for all the clubs (from 1:00 p.m. to 4:00 a.m.).

Klassman, in his typical fashion, sued the other clubs for breaking what he contested was the gentlemen's agreement to stick to the plan of the staggered closing days. The agreement, he argued, had been made between the clubs after the Sunday closing provision was removed from the city's ordinance. Klassman filed a claim in Los Angeles Superior Court demanding $750 a week damages for his estimated lost profits. When Primm's Rainbow Club was the first to announce it would be reverting back to a seven-day operation, Klassman undoubtedly took extra exception with Primm for leading the charge.

Primm had his own problems. A long-standing disagreement had erupted among the partners of the Monterey Club, leading to the club's closure and bankruptcy. W.L. Tooley had decided to bring a suit for accounting against his five partners, charging that the Monterey had been operating at a loss for some time. Unable to pay the city for its table fees, the logical outcome was to order the club's closure and sale.

One of the chief reasons given to the bankruptcy court receiver, who was designated to accept bids for the business, was that the Rainbow Club—formerly closed on Tuesdays—was now open on Tuesdays, resulting in the Monterey taking a $2,000 loss every week from the added day of competition. Tooley charged that his partners had violated the city's ordinances and, among other things, had allowed illegal wildcatting to go on at the Monterey and were responsible for provoking Klassman's lawsuit for reneging on the staggered closing day plan. The bankruptcy court estimated the value of the Monterey Club at $71,840.

Ernie Primm (*left*) and Sam Kronberger inside the Rainbow Club. *Blaine Nicholson*.

At a January 1955 auction, Primm swooped in and placed the winning bid, successfully acquiring the Monterey Club for $110,000. The sale was contingent on the Monterey's license being transferred to Primm. His lawyer, Dudley Gray, made swift arrangements with the Gardena City Council to see that the transfer went through, making Primm the club's sole owner. Gray indicated that there would be more partners in the future, and on January

18, 1955, the club reopened under the management of new partner Alan Roberts. Roberts had cut his teeth managing the Normandie, Horseshoe and Gardena Clubs.

The Monterey Club also featured a new upgraded look after being decorated by the Morris and LaRoe company of Huntington Park. The old driftwood and planter interior had been replaced with a lighter décor that utilized a Persian theme in the card room, with new color schemes being employed in the dining room, the television room and the men's and women's lounges.

Primm's rivalry with Klassman resumed during the spring of 1955 when the Monterey and Embassy Clubs made headlines and national television news by waging a food war of slashed prices designed to poach customers from each other. The Monterey started the exercise by offering a "players only" three-day fifty-cent lunch special, only to be countered by Klassman's Embassy Club, which dropped the price of its lunches down to a single dime. It's estimated the Embassy sold ten thousand dime lunches to excited diners

Monterey Club dining room interior. Many of the old paintings that adorned the walls of the Monterey can now be found on display at the Bavarian-style complex Alpine Village in Torrance, California. *City of Gardena Archives.*

who were lined up—at times 150 deep—to take advantage of the most sensational food bargain since the soup kitchens of the Great Depression. A sample of the cut-rate menu consisted of beef stew or a tomato stuffed with tuna salad plus a choice of coffee or milk.

Some card club operators even accused the Gardena Yellow Cab company of having its drivers distribute ten-cent meal tickets for use at the Embassy Club. Klassman, conveniently confined to his home with a cold, reported that he had no intention of putting his prices back up, even though the other clubs had resumed normal pricing. An angry Mayor Bolton charged that the price cuts were in gross violation of the law and could cost club owners their licenses if normal prices weren't resumed immediately.

Eventually, the city got the clubs in line, making them forge a peace pact that included fixed food prices and a return to the staggered closing days. The new schedule went as follows: the Normandie Club would close on Sundays, the Embassy Club on Mondays, the Gardena Club on Tuesdays, the Horseshoe and Rainbow Clubs on Wednesdays and the Monterey Club on Thursdays. The price war stunt did little to benefit either the Monterey or the Embassy, as neither reported a significant spike in card players. If anything, it had the negative effect of thrusting Gardena into the national spotlight at a time when lawmakers in Sacramento were building support for a vote to outlaw commercial draw poker throughout California.

By April 1955, the State Assembly had voted 55–9 in favor of outlawing poker with a bill drafted by freshman assemblyman Jesse Unruh, a Los Angeles Democrat, clearly aimed at Gardena. California's Republican governor Goodwin Knight said, in support of the bill, "I am in favor of that, and if the bill passes, I'll sign it. I think draw poker is a bad thing in the community." The vote marked the third time in four years that the assembly had passed anti-poker legislation.

Gardena's own assemblyman, Clayton Dills, sounded off against the measure, declaring, "There's gambling going on all over the state, but they pick on one little town." Dills argued unsuccessfully to amend the bill so that draw poker could be played legally if a city voted to permit it, even if it was banned by the state. Fortunately, the measure only got as far as the Senate Governmental Efficiency Committee in Sacramento, which unanimously tabled it, stating that issues of commercial draw poker should be settled by the people of areas that are home to card clubs.

Assemblyman Frank Lanterman, of LaCanada, fired back, proposing an amendment empowering Los Angeles voters to impose a countywide ban on poker. The bill proposed anti-poker reform through charter changes in

Los Angeles and ten other chartered counties. It was heavily opposed by the League of California Cities because it allowed the county to override city ordinances. Several representatives from Gardena traveled to Sacramento to oppose the bill, including Gardena attorneys Don Davidson and Dudley Gray, Mayor Adams Bolton and councilman Robert Shelby. Bob King, the defeated city council candidate who had waged war on the card clubs during the last city election, addressed the committee favoring the bill and presented a petition of some six hundred names also in favor. The bill ultimately failed in a committee vote of 3–2. This was the third time in four years that the Senate Governmental Efficiency Committee had killed anti-poker legislation.

The year 1956 was rife with hostility in the Gardena card club industry, including a two-day strike and picketing by members of the Local 814, Culinary Workers and Bartenders Union, AF of L, over "unsatisfactory working conditions." A new free meal war had erupted over accusations from Klassman that Primm had violated the card club owners' agreement of remaining closed one day a week. As a result, Klassman's Embassy Club was now offering free meals and waiving table fees for players in an attempt to attract more business and recoup what he perceived were losses brought about by Primm's extra opening day. Quick to call the free meal bluff, Mayor Bolton fired warning shots:

> We don't care what the poker operators quarrel about as long as they don't damage the residents or other businessmen of the town. But when legitimate café operators complain about free meals, we're going to put a stop to it—and mighty quickly, too.

That spring, under the leadership of newly elected mayor Thomas Ware, a committee was assembled to study the card clubs and determine a set of recommendations for strengthening the governing regulations. The strongest objections to this exercise came from Primm and George Townsend, owners of the Rainbow and Monterey Clubs. They vehemently protested the fact that Bow Herbert had been selected to join this committee as a representative from the Gardena card club industry, arguing that there was no way Herbert could be impartial or fair based on his own interests.

It was a petition to the city council from Herbert that had prompted the whole affair, resulting in his selection to join the committee. Herbert had declared that an ordinance revision was necessary to protect the industry from itself, suggesting the internal conduct of the clubs was not always

aboveboard. Longtime Gardena resident Maurice Schroder spoke out of frustration at a council meeting: "The card clubs bring this trouble on themselves. Every year, the council is beset with the squabbles of these men. The citizens of this town will soon tire of their petty fights and vote them right out of town!"

Based on its findings, the committee recommended eight items to the council, which in turn drafted letters to the club owners proposing they give feedback on these suggestions before they became law. The owners unanimously responded that the matter should be shelved or postponed. In January 1957, the following angry editorial piece ran on the front page of the *Gardena Valley News*:

> *If the City Council expected card club owners to come up with any helpful suggestions relative to a revised card club ordinance they were sadly disappointed.*
>
> *In four letters received, one from Harry Klassman of the Embassy, one from Bow Herbert of the Gardena and Horseshoe, and two from an attorney representing the Normandie, there was not one constructive suggestion....*
>
> *In our opinion it was a waste of time in the first place to ask the card clubs for any suggestions concerning an ordinance which they obviously did not and do not want. This is particularly true because the card clubs have given feeble evidence in the past that they are interested in getting along with each other....*
>
> *This newspaper has reason to believe interested legislators in Sacramento, as well as the State's Attorney General, have been fully briefed on the controversies and alleged irregularities credited to the local card clubs. It is impossible to keep this sort of thing from our lawmakers.*
>
> *If there are conditions in our card clubs which need rectifying, then the faster firm action is taken the more likely it is that lawmakers at the state level will keep hands off. If, on the other hand, there is evidence that the city council is so vacillating that it cannot or will not take the proper regulatory action, then it is indeed time for outsiders to take a hand in the matter.*

As an undercurrent of anti–poker club sentiment surfaced in the press, with allegations that the city government was really under the control of the clubs, the Gardena Civic Improvement Committee (now calling itself the Civic Improvement League) once again began the process of garnering support for the ouster of the clubs. By the fall of 1957, notice of a petition to outlaw the clubs was filed with the city by the organization's chairman,

Bobby Kenneth King. King would need to collect 1,002 signatures to place the issue on the ballot for the forthcoming municipal election. The public notice gave reasons prompting the petition, including:

> *The existence and operation of the Gardena card clubs has allegedly led to acts of murder, armed robbery, bookmaking, suicide, embezzlement, prostitution, and local suppression of crime reports. The connections between these illegal acts and the City of Gardena has led spokesmen for the California District Attorneys and Peace Officers Association to call Gardena "a breeding place for organized crime" and "a place which attracts syndicated criminals." Two Governors, Earl Warren and Goodwin Knight, have denounced the card club operation as "an affront to public morals."*

Vice chairman Robert Ellis also charged that the city's list of registered club partnerships was not up to date and in violation of the ordinance. Citing the lists on file with the city clerk's office for the Rainbow and Monterey Clubs, Ellis argued, "They even have a man listed as a partner who has been dead for over a year. If these lists aren't up to date, how do we know some mob hasn't infiltrated the clubs and is operating them?"

With the help of forty-three men and women circulating the petition door-to-door in each of the forty-one precincts within Gardena, the Civic Improvement League filed a 1,472-signature initiative petition with city clerk Lucille Randolph in January 1958. She determined that 1,293 of the signatures were valid, guaranteeing the measure would make it to the April municipal ballot. The last time the poker club question had been put to the voters was in 1946, and at that time, the clubs won by the slim margin of only six hundred votes.

In January 1958, local accounting firm Kaji, Okuma, Hanaoka & Company assisted the *Gardena Valley News* with a public opinion poll designed to gauge public support for the new ballot measure. Results showed the vast majority of citizens polled answered "No" to the newspaper's question: "Should draw poker be abolished in Gardena?" favoring the card clubs by a vote of 2,528 to 78.

In the lead up to the election, a local political aspirant named Don Mario addressed the city council, publicly denouncing the card club–opposing Civic Improvement League. Mario, a longtime Gardena resident with a background in theater, was greeted by loud applause from those in the chamber as he prepared to read his three-page speech.

> *In a society such as ours, we are at a disadvantage when a GADFLY can come in under the mantle of protection and use a public forum for selfish aims. But, in this country no man has the legal or moral right to dictate to his neighbor. I think it is quite obvious to the community that in this instance Mr. Ellis and Mr. King are attempting to use this legislative body for partisan political purposes....*
>
> *And just who are these men—Mr. King and Mr. Ellis, president and vice president of the Civic Improvement League?*
>
> *I'll tell you who they are.*
>
> *Mr. King appeared in this community five years ago. He had never held public office, having been overwhelmingly rejected by the voters of this city in the elections of 1954. He earns his living outside Gardena and has no identification whatsoever with local service or organizations. Mr. Ellis is a transient and not even a registered voter in this city.*

Opposition to the Civic Improvement League also came from a new group, the Gardena Taxpayers Fact Finding Committee. The pro-card club periodical *Gardena Record* from April 1958 featured a political advertisement by the group, advising voters, "Gardena Citizens Mark Your Ballot to Keep the Card Clubs and $300,000 of City Revenue. Be sure and vote NO on 1 and 2."

Mayor Ware took the extra step of explaining measures No. 1 and No. 2 on the April ballot by way of a statement from his office published in the *Gardena Valley News*. It pointed out to voters that if the card club ban was adopted, the city would have to raise taxes in order to make up for the loss of $300,000 in card club revenue.

> *Measure No. 1 is a permissive tax ordinance that gives the City Council the authority to raise local property taxes to $1.81 per $100 of assessed valuation. In a sixth class city public approval must first be obtained where taxes exceed $1.00 per $100 assessed valuation.*
>
> *Measure No. 2, if adopted would prohibit the legal card clubs from operating.*

The mayor declared, "I am confident the people of this city will discharge the responsibility involved and in their decision contribute to the future of this community."

On April 9, 1958, Gardena residents defeated both measures 1 and 2 in a landslide 3–1 vote, ensuring the survival of the Gardena poker clubs for

Ernie and Evelyn Primm. *Blaine Nicholson.*

the foreseeable future. Councilman Bolton was also returned to the city's highest office, as the council once again reelected him mayor of Gardena on April 15. Bolton, a sixteen-year veteran of the city council, had spent eight of those years as mayor.

During the summer of 1952, Primm married his second wife, Evelyn Johnson Primm, who had formerly graced the covers of many national magazines as a New York Barbizon and Conover Agency model. The couple settled in Gardena, where Evelyn shone as the perfect trophy wife, particularly due to the glamorous nature of Primm's businesses.

Evelyn made headlines as a private pilot, an excellent golfer, a water skier, a horsewoman and a champion sharpshooter. She recorded the highest ever score—for a man or woman—on the twenty-seven-yard range, a feat for which her husband, Ernie, was reported in the press to have rewarded her with a platinum mink stole.

In 1958, Evelyn Primm made her way onto the international stage when the National Amateur Trapshooting Association selected her as one of five members to represent the United States and the only woman to represent any country at the world's championship trapshooting contests in Stockholm, Barcelona, Paris and Moscow. As Evelyn boarded her Scandinavian Airlines

flight to Sweden, she remarked to the assembled reporters, "I am proud and pleased to have been chosen and I will do my best to make my country proud," a comment sure to have added to Ernie Primm's luster in the communities where his gaming empire thrived.

As Evelyn prepared to compete against the world's trapshooting elite, her husband was taking aim at his own competition. In a bold attempt to put his Gardena competitors out of business, Primm approached the city council with a proposition to increase table fees from $1,000 to $1,400. According to Primm, the measure would be a means of accruing extra revenue to build the city a municipal swimming pool and a new city hall and for other capital improvement projects.

Legal representatives for the Normandie, Embassy, Gardena and Horseshoe Clubs protested the blanket tax, arguing for a more equitable gross revenue tax instead. Klassman went before the city council to protest the tax hike, maintaining it had been orchestrated by Primm to prevent his competition from expanding their enterprises. He argued that the Embassy would be hit the hardest, and he "didn't want to be taxed out of business." Primm's successful Rainbow and Monterey Clubs could easily afford the hike, but for the Embassy, Normandie, Horseshoe and Gardena Clubs, it would be a huge financial stranglehold.

When the council approved the rate hike, Klassman threatened to sue Primm, the city council and newly reelected Mayor Bolton, charging that he would take the council to the grand jury on the grounds that they were "crucifying the four clubs…and acting arbitrarily and unfairly toward the owners." Bolton pushed back, asserting that license fees hadn't been raised in the city for six years.

That same month, Klassman was himself the subject of two lawsuits, the first brought on by his dentist, Dr. Edwin Broffman, who claimed he had given Klassman an investment of $33,000 for a 6 percent stake in the Embassy Club and failed to receive any return income. Broffman's attorney accused Klassman of fraud, stating, "I wonder just how many points Mr. Klassman has sold; there are only 100 points allotted each club and I certainly wouldn't be surprised to find Klassman has sold as many as 600."

Klassman was also sued by Jim Cullen, a political consultant who provided services to the six card clubs during the last election. The suit alleged that Klassman failed to pay his share of Cullen's salary during the twelve months he worked for the clubs. Each of the clubs was paying Cullen $200 per month and splitting the cost of his $20,000 in operating expenses.

A High-stakes History

Ernie Primm (*right*) became Gardena's biggest philanthropist. *Blaine Nicholson.*

In November 1958, the American Veterans (AmVets), represented by William Kurtz, and the Nisei VFW, represented by Toshiro "Tosh" Hiraide, joined forces in a joint request to the city council for an amendment to the card club ordinance permitting a seventh card club license. The two organizations requested they be allowed to share the license and split the proceeds. Kurtz told the council, "What we're after is the same chance to further the service and welfare work for our groups that the Legion and VFW post is now offered."

The council had received a similar request earlier that year when a local group, the Afro-American League, lobbied the city to grant a seventh license to establish Gardena's first black poker club. The request was denied on the grounds that there wasn't enough business to support a seventh club in the crowded Gardena poker arena.

Joe Hall, a former partner in the Normandie Club, still held the lease on the Western Café. He aligned himself with the two veterans' organizations,

indicating that he would finance a new club at the Western Café with the use of a seventh license. A spirited debate followed, with representatives from the clubs and city weighing in heavily against the request. Local attorney Edmond Russ argued before the council: "I oppose it. Where would we draw the line? Why just seven? Every fraternal organization and service club would apply."

As if Russ had tempted fate by saying it, a request for an eighth club license came from the local branch of the Fleet Reverse Association, a veterans' organization composed of men with at least six years of service in the U.S. Navy or Marine Corps. Sam Kronberger, head of the organization, reasoned, "If the city council decides there is enough business for another card club, then we'd like a share of it too."

Primm's attorney, Dudley Gray, bowed his head in anguish, wringing his hands as he listened to Kronberger throw a wrench into the discussion. As the conversation progressed, Kronberger explained that he didn't want to compete with the other organizations, as he held the highest admiration for Nisei Post 1961 and for the AmVets Post 30 Auxiliary. When Councilman Jensen inquired if the group had the use of a building for a card club, Kronberger replied airily, "We're broke. We don't have $10….We're just a bunch of broken down sailors." Upon hearing this, an elderly man in the back of the room climbed out of his seat, yelling, "Let 'em all in! Why not throw it open for everyone?"

These requests ended up being the first shots fired in a lengthy political battle that would bleed into 1960.

After openly supporting the request for a seventh club license, Councilman Jensen came under attack from a newly formed civic group calling itself the Better Government League. The group's leader, George Russell, targeted Jensen over his support for a seventh club, calling for a recall petition to unseat him. "We get awfully tired of having others refer to Gardena as a Little Las Vegas. All I can see from this proposed new club is a lot of bad publicity," Russell charged. Russell was joined in his opposition to the seventh club by Robert King and Robert Ellis, leaders of the now dormant Civic Improvement League. Undeterred, Jensen introduced the amendment that would permit the seventh club.

By the end of November, the Better Government League announced plans to open headquarters on Redondo Beach Boulevard for the purpose of circulating its petition against the new club. Russell indicated that he had financial backing for the campaign but declined to tell the press from where he had secured his funding. Shortly afterward, another familiar

organization, the Gardena Taxpayer's Fact Finding Committee, entered the fray in support of Councilman Jensen, with claims that the seventh club would provide $1,200 per month for the veterans' groups and an additional $65,000 annually for the city treasury.

In mid-December, sparks began to fly in the political battle, as Harvey Chapman, a lanky professional golfer turned city councilman, stormed out on the council moments after Jensen's seventh club amendment gained a 3–2 approval vote, paving the way for the new club to open in early 1959. Chapman charged, "Somebody apparently wants a political battle and they're going to get it," accusing fellow councilmembers Jensen, Ware and Mayor Bolton of being firmly in Primm's pocket.

Chapman believed that Primm was secretly playing puppet master in an attempt to control what would be his third Gardena card club. When Chapman cited a petition in support of the new club circulated by employees of the Rainbow and Monterey containing 1,300 names, Attorney Dudley Gray denied that Primm had any interest in the new club. He made it known that Primm instead had "plans for a $1,000,000 gambling casino at Border Town, on the California-Nevada state line." Gray went on to explain that Primm had already gone as far as drilling four water wells on the four hundred acres he owned forty miles south of Las Vegas.

The Embassy, Gardena, Horseshoe and Normandie owners banded together to fight the new club initiative, claiming to have a combined budget of $50,000 for an anti–seventh card club campaign. The Horseshoe Club even attached notices to employees' paychecks instructing them to canvass their neighborhoods to determine public support for and against the new club.

As 1958 came to a close, Mayor Bolton appeared on the local evening news, positing a "behave or get out" stance on the matter of the opposition efforts. In his interviews, Bolton explained that he felt the addition of a seventh club was definitely in Gardena's best interest and offered this ultimatum: "Either clubs opposing the issuance of seventh card club license as approved by the city council withdraw their opposition, or I'll lead a fight to ban them all from operation."

But in January 1959, the four dissenting clubs struck back, presenting a referendum petition containing four thousand names to the city clerk's office, effectively stalling the council's approval for the new club. With this many opposing signatures, the council was forced to decide between turning the decision over to the vote of the people or allowing Mayor Bolton to act on his promise of banning all card clubs from Gardena.

Church groups were quick to assert their unanimous support for Mayor Bolton's card club ban, resulting in the Gardena Valley Ministerial Association urging the mayor to put the question of club ouster on the referendum ballot. Under the leadership of Reverend H. Leon Berry, minister of the First Christian Church, Gardena Valley Ministerial Association members moved to give Mayor Bolton their full support against what they deemed a moral detriment. Reverend Berry justified the association's support for Bolton, stating, "I and my fellow clergymen feel that not only is this detriment moral but also hurts the city financially in that businesses who might otherwise locate here shy away from the community because of the gambling element."

At a mid-January council meeting, Mayor Bolton reported that he had been threatened by persons close to the opposing four clubs, receiving late-night phone calls at home in an attempt to scare him off his stance. In a police report, he claimed that Bernard Van Der Steen, owner of the Normandie Club, had been one of these abusive callers, purportedly hurling obscenities at him for threatening to drive the clubs out. But when Bolton's question of voting the clubs out was put to the council, the proposition fell on deaf ears, with no seconds from the other councilmembers. Mayor Bolton closed the meeting, hinting that the clubs might not have heard the last of his efforts to oust them and there was a good chance it would appear as a measure on the next general ballot.

As the council prepared for the seventh club license measure to go forward on the April ballot, Councilman Chapman argued that Bolton's political views had been bought by special interests within the city, charging, "I'll show you where your money has come from for four elections." Reinforcing his view that Primm was working behind the scenes to orchestrate the passage of a seventh club license, Chapman angrily quipped, "Twenty clubs would be better than having three controlled by one man." When asked about maintaining his pledge to oust the clubs, Mayor Bolton indicated that his response would depend on the behavior of the clubs between then and 1960.

As the date of the vote approached, other organizations began to express interest in the potential seventh card club license. One such party was black newspaperman James Goodson, publisher of the *Los Angeles Record* and a member of the Afro-American League. Goodson sent the Gardena City Council a letter, stating, "The Afro-American organization and this newspaper is officially notifying you that it will apply for a license if a seventh card club is approved." Goodson went on to say in his letter that if

his group was not granted the seventh club license, the organization would be interested in pursuing an eighth club license.

Weeks later, Goodson's card club application was openly attacked at a Gardena City Council meeting by Cornell Ridley, a black attorney associated with the National Association for the Advancement of Colored People's Redress Committee. Ridley accused the *Los Angeles Record* newspaper of inciting race hatred, charging, "You people here have never heard of this newspaper before certain political groups used it for their own advantage. This is an attempt to lower race relations and violates everything the NAACP stands for. It's a scurrilous attempt to degrade our race."

Ridley angrily referred to a paid political advertisement that had appeared in the *Gardena Valley News* stating that the Afro-American League would pursue an eighth club license should voters here approve a seventh permit, denouncing the ad as "race baiting." William Kurtz, attorney for the AmVets, took to the floor, pointing out to the council that somebody from the opposition had been mailing Gardena residents copies of the *Los Angeles Record* issue containing the Afro-American League's eighth club statement along with a piece of anti–seventh club literature.

Goodson was also admonished by Varnoy Thompson, president of the NAACP's Compton chapter, after making claims that the NAACP would somehow be involved in helping to promote his new card club to African Americans. Thompson angrily told the press that Goodson was "in no position to say what we will or will not do," adding that the NAACP was dedicated to fighting for civil rights and had no interest in opening any casinos. "We don't want any part of gambling casinos in Gardena or anywhere else," Thompson concluded.

After six months of political infighting and many thousands of campaign dollars spent by the opposition, on April 28, with only a 50 percent voter turnout, the seventh card club license was finally approved by 5,917 voters, with a 579 plurality. An elated Joe Hall and Ernie Primm were on hand at city hall to witness the verdict.

Primm had mailed out a last-minute citywide appeal to voters, urging them to vote in favor of the new seventh license, and many in the know credited this move as turning the tide for voters to the affirmative. With the AmVets–Nisei VFW Posts still the most likely candidates for the new license—since they had sponsored the affirmative side of the campaign and Hall still lined up to operate the new club—the question of where the new club would be located resurfaced. When the press asked about using the site of the Western Café, Hall replied, "I'm just not sure at this point."

Four requests for the seventh club license were filed at city hall in time for the June 5 deadline. Those that made the filing deadline were the AmVets–Nisei VFW Posts (a joint application), James Goodson, Gardena Youth Activities Inc. and Edward Blair, a local building contractor. A fifth request from prospective applicant Beatrice Reeves failed to materialize after she reported having difficulty in finding a suitable location for her club. The fourth contender, Edward Blair, eventually dropped out ahead of the council's decision, remarking, "I just think there are some good organizations applying and would rather see one of them get the permit."

Tom Parks, former journalist turned press agent for the Horseshoe and Gardena Clubs, and Bow Herbert had formed the new philanthropic organization Gardena Youth Activities Inc., which purportedly set its aim as the furthering of scholarships and sports activities for the boys and girls of Gardena. Both Parks and Herbert asserted that the purpose of the new youth group was not to get its hands on the prized seventh club permit and plans for the association had been in the works long before the new license ever made news. Parks assured the press that they would plan to go ahead with the association with or without the club permit.

The election was followed by a long, hot summer of litigation, delaying the issuance of the new license. It started with a taxpayers' suit launched by Tom Parks against Mayor Bolton, four city councilmen and the city clerk, designed to nullify the election results. The suit alleged that campaign funds spent by those favoring the new club confused and intimidated some one thousand voters so much that they didn't even go to the polls.

A second suit came from Albert Pearlson, attorney for the Gardena and Horseshoe Clubs, who contended in front of a superior court judge that Mayor Bolton's "all or nothing" stance on the clubs had resulted in a form of voter intimidation.

Finally, James Goodson's camp filed a restraining order preventing the city from issuing the license to any group until a court could rule on whether or not the Gardena City Council had already predetermined the recipient of the seventh card club license.

Albert Pearlson's intimidation suit was quickly dismissed because the intimidation factor was not of a physical kind and could not be proven as a deciding factor for voters. However, the Parks and Goodson cases raged on into the summer months, prompting Gardena city attorney Don Davidson to seek reinforcements in the form of associate attorney Walter Anderson. Anderson was the city attorney for Manhattan Beach and president of the South Bay Bar Association.

A High-stakes History

In a surprise turn of events, it was discovered that Normandie Club owner Bernard Van Der Steen had been a silent partner in James Goodson's application. City hall records revealed the proposed address listed on Goodson's card club application to be a property owned by Van Der Steen. Goodson later admitted he had been given the $10,100 deposit for his license application by the Normandie Club's press agent, Charles Amador.

When Van Der Steen and Amador were nowhere to be found during the court proceedings, South Gate Superior Court judge John McCarthy issued three warrants for Van Der Steen to appear at the court, but the warrants were returned by the sheriff's office, which reported that Van Der Steen was on an extended trip to Nevada. To complicate Goodson's application further, after weeks of his $10,100 deposit being on file with the city, numerous creditors lined up to attach themselves to those funds, tying up $9,000 of the money in liens.

After weeks of reviewing evidence in the cases, Judge McCarthy's decree was that the section of the ordinance limiting the number of clubs in Gardena was unconstitutional. McCarthy's view was that Gardena, by putting a cap on the number of clubs allowed, had created a monopoly among club owners. The judge arrived at this ruling when he interpreted the club law to read that no poker operation would be considered a public nuisance and therefore there could be no legal reason for limiting their number.

The South Gate Court decision meant that any and all were entitled to licenses, but the city quickly went ahead with granting the seventh club license to the Nisei VFW–AmVets Posts in a 3–2 vote, sparking outrage from their competitors. The Gardena Youth Activities Inc. demanded that an eighth license be granted to the organization, filing a writ with the city council signed by Judge McCarthy. The city turned them down, sticking with its decision to limit the number of clubs to seven. City associate attorney Walter Anderson explained, "Until a District Court of Appeals or the Supreme Court itself rules on this ordinance, we're not going to issue any more permits."

As the dust was settling from months of legal action, Joe Hall relocated his building plans for the seventh club, choosing a piece of newly annexed property just north of the Rainbow Club. A potential opening date of February 1, 1960, was announced as construction crews broke ground demolishing what had been an old trailer park. Early design renderings of the still-unnamed club showed a modern space age design, involving expansive landscaping and widespread use of structural glass. The addition of the new club next to the Rainbow and Monterey would effectively create a card club row along Vermont Avenue.

After being abandoned by several key staffers who openly charged that the Gardena Youth Activities Inc. was a thinly veiled front for the Horseshoe and Gardena Clubs taking advantage of Gardena's youth by posing as a philanthropic organization, the group took the City of Gardena to task in Inglewood Superior Court, continuing its fight for an eighth club license. However, the Gardena Youth Activity Inc.'s license bid came to an end when Inglewood Superior Court judge Eugene Fay slammed a lid on all future Gardena card club requests, contradicting the earlier opinion of Judge McCarthy.

Meanwhile, Bow Herbert faced a mutiny of his own, as his partners in the Horseshoe Club took legal action against him and attempted to put a court receiver in his place, accusing Herbert of gross mismanagement of funds. The complaint against Herbert alleged that he had secretly received rebates from the club's vendors in an attempt to increase his $75-per-day-salary. The complaint further alleged that Herbert had charged the club's partners with over $1,500 in public relations bills—funds which the partners believed were being used illegally and improperly. The partners felt Herbert's quest for another club license was a severe conflict of interest for the Horseshoe Club.

In January 1960, the *Gardena Valley News* challenged Herbert for his involvement in the battle of the seventh club license. An open letter published in the newspaper accused Herbert of playing with fire. The newspaper took exception with a recent mailer sent anonymously to the citizens of Gardena titled "The Gardena Guardian," describing it as campaign propaganda that suggested the ban of all card clubs. It also suggested that the mailer had been generated by Herbert's press agent, Tom Parks. *Gardena Valley News* publishers W.J. Hunt and Don Algie posed this question to Herbert:

> *Are you or your associates engineering a colossal bluff in an attempt to* (1) *frighten your limited partners into abandoning their lawsuit against you, or* (2) *scare the AmVets–Nisei VFW club operators into hollering "calf rope" and retiring from the field?*

Momentum for putting the card club question to voters for a third time began to build. Months of negative headlines and the monopolization of the city's political resources had soured public opinion and made the clubs more vulnerable than ever for a new political coup. George Liebsack, former American Legion commander and a local auto mechanic, filed a notice of intent to circulate a petition against the clubs—seeking 1,200 signatures to

get it on the April 1960 ballot. Liebsack pledged an all-out effort to "see if we can't do without them," explaining, "Many people are sick and tired of the publicity, notoriety and squabbling of these card clubs."

Liebsack, who arrived in Gardena in 1943 and formed his own business, the auto repair shop Leibsack and Son, had played an important role in the industry some years earlier when he signed the operation agreement between the American Legion and Herbert for the Horseshoe Club. The new petition received heavy endorsement from the Gardena Valley Ministerial Association and the support of participating congregations, which helped circulate it. By mid-February, Liebsack had collected 1,773 signatures (1,545 were later verified by the city clerk) in support of the anti–card club measure and got it on the April ballot as Proposition A.

In the lead up to election day, two strange incidents occurred that seem noteworthy in retrospect. The first was the discovery of a ticking time bomb in a vacant lot by neighbor Clara Brown, who immediately called the police, screaming down the phone, "It's ticking like mad!" Police who arrived on scene, ready to defuse a bomb, quickly discovered it to be a battered old coin-operated timer mechanism—possibly a crude test for a real bomb. The next incident involved the theft of a large safe from the offices of the Primm Investment Company on Vermont Avenue. During evening patrol, Compton police officers happened to find the stolen safe standing in the middle of the street. Burglars broke in through the front door of Primm's office and pushed the large safe out the back door. After breaking into the strongbox, they removed $225 in cash before dumping the safe in nearby Compton. The safe also contained private company records, which remained intact after the robbery.

The March 20 edition of the *Los Angeles Times* featured an article on the construction of what was to be Hall and Primm's joint venture, the newly named Starlite Club. The article touted, "Construction has started in Gardena on one of the most unusual buildings in the country," praising the futuristic design by Los Angeles architects Armet & Davis. A pro–card club political ad by the Gardena Taxpayers Fact Finding Committee that appeared in the *Gardena Valley News* shortly before the April election urged citizens to vote "No" on the anti–card club measure and to "keep what you the voters have established," referencing the Starlite Club as a coming attraction that would enrich the city.

In a desperate act to stop Primm from monopolizing the local card club industry with the construction of the Starlite Club, the Embassy, Horseshoe, Gardena and Normandie Clubs did the unthinkable, banding

Architectural rendering of the Starlite Club. *Armet & Davis, A.I.A. Architects.*

together and masquerading as an anti–card club citizens group. They began a kamikaze process of circulating petitions urging the closure of all the clubs—including their own.

At 11:30 p.m. on Tuesday, March 22, a bomb exploded outside the south entrance to the Rainbow Club, rocking the five-square-mile city and causing $3,000 worth of damage to the Rainbow and Monterey properties. The bomb blast ripped away the Rainbow's south entrance door and canopy entrance roof, opening a ten- by fourteen-foot hole in the side of the building, breaking mirrors and decorative glass and overturning furniture inside. An eighty-foot expanse of windows running along the front of the club was shattered. Several large windows were also shattered on the adjacent Monterey Club, along with the windows in a bus shelter located in front of the clubs.

Acting on vague tips, police captain Roy Tracey reported that he was investigating two leads: one involving a man and his wife who were having an argument in the area and another where an eyewitness saw a mystery car speed into the Rainbow Club driveway shortly before the explosion.

The bombing occurred on a night when the clubs were closed as part of the staggered closing day agreement. Whoever planted the bomb did so knowing that they wouldn't injure any card club patrons. On an open night, there would have been between three and four hundred people in each of the clubs playing at that hour.

A High-stakes History

John Dahline, a fifty-three-year-old security guard who was on site making his rounds through the darkened club when the blast occurred, missed serious injury or death by a narrow five minutes. Dahline described the events from his perspective:

> *I had just been through the club and had returned to a front office when the bomb went off. The blast knocked me from my chair and I first thought that a plane had crashed somewhere close by or that it was a jet sonic boom. When I looked into the main room of the club I saw smoke from the location of the explosion and realized what had happened. I heard or saw nothing on my last round before the bomb went off.*

The only other soul inside the Rainbow Club that night was a maintenance man named Walt Sego. Miraculously, Sego had slept through the explosion, as he was taking a nap in one of the club's restrooms. He didn't awake until Dahline came searching for him after the blast. Sego's car, parked fifteen feet from the detonation, was lifted five feet into the air and had its windows splintered. Across the driveway at the Monterey Club, Joe McLaughlin, the only guard on duty, was knocked off his feet by the blast. His injuries included cuts, scrapes and a broken eardrum.

Captain Tracey felt the force of the blast from two miles away at the Gardena police station. He immediately called in a squad of demolition experts from nearby San Pedro's Fort MacArthur, headed by Lieutenant John Callighan of the Fifty-Eighth Ordnance Detachment. Callighan found artifacts from the bomb in the rubble, including red dynamite stick wrappers, which went to the sheriff's crime lab for further investigation. The army ordnance expert estimated the bomb was composed of six to ten dynamite sticks or half a pound of nitroglycerin. He concluded that the bombing was not done by an explosives expert, as the device could have been far more effective in its blast radius if it had been left to go off in a more confined area. The exposed position of the bomb next to the front door resulted in a fifteen-inch-deep blast hole in an outside flowerbed but less damage to the building structure.

Primm, who was well aware how detrimental this incident would be for the entire card club business in the run up to the election, quickly dismissed notions that it had been the work of anti–card club campaigners: "I'm sure that none of the Gardena people who have been opposed to operation of the clubs would have anything to do with such a thing as this….It must have been a misguided fanatic, or some sensation-seeking youths."

The Rainbow Club promptly put up a $5,000 reward for information leading to the bomber's arrest and conviction, but none of the leads ever proved successful. Repairs on the clubs were underway within two hours of the explosion, and the Rainbow and Monterey both opened for business hours later on Wednesday morning.

Ironically, the bombing had interrupted a heated city council meeting at Gardena City Hall, where opponents and proponents of the card clubs were bitterly arguing their opinions. George Leibsack quickly condemned the attack, stating, "Our group is not given to violence. We had no hand in it. We are out to beat them at the polls."

Sensing the end was near for the card clubs, the other owners ended up relying on Primm's political prowess to save himself, and them, from being put out of business forever. A week before the election, the club owners released a joint press statement announcing an unprecedented pact between themselves that would signal the beginning of a new era of harmony and unity. As part of the truce, the clubs agreed to abandon all pending court actions and proposed a new business volume tax. Under the new agreement, the larger clubs would now pay nearly triple the amount of tax. The new more equitable schedule consisted of $1,000 per month per table in addition to a monthly tax of 2.5 percent on a gross of $80,000 to $100,000; 3 percent for $100,000 to $200,000; and 3.5 percent on a gross over $200,000.

Upon news of the pact, Mayor Bolton expressed his approval to the press:

> *If the clubs receive the approval of voters at the April 12 election, this attitude of harmony among them will prove of great value to our community. I hope we can look forward to more constructive evidence of their unity in the future, and that they will join with all other progressive interests in Gardena to promote our future prosperity and civic betterment.*

Primm explained later that the major negotiation between the owners before they had all agreed to the pact was to reduce the number of active clubs to six. The provision that Primm would close down the Monterey Club in time for the opening of the new Starlite Club was what sealed the deal for all involved. Primm planned to suspend or cancel the Monterey license in favor of using the new Nisei VFW–AmVets license, paying the groups $18,000 per year for its use. Under the new terms, the city would now receive more than $500,000 annually.

On April 12, the anti-poker measure was defeated in a close vote, retaining the clubs' existence by a slim margin of 810 votes, only a 54

percent majority. In the aftermath, both sides were acutely aware that had 406 citizens switched their position to voting "Yes" on Proposition A, the lavish Gardena poker palaces would all be closed.

Feeling relieved to be still in business, Herbert told the press:

> *I, together with the entire personnel of the Horseshoe and Gardena clubs, am very grateful to the voters of Gardena for letting us stay in business. The results of the election, however, indicate to me and my associates very strongly that the community of Gardena is demanding complete unity between the card clubs or we may lose the privilege of staying here as an industry.*

Shortly thereafter, construction work on the new Starlite Club was halted. Some speculated that the $700,000 construction project stopped because Joe Hall was disturbed by the closeness of the vote. Hall also owned several Las Vegas gambling clubs, including the Lucky Strike and the Mint. When contacted by the *Los Angeles Times* about his future in the Starlite Club project, he indicated that he was pulling out of the Gardena card club industry, saying, "I'm sticking to Vegas from now on." The seventh club was never built, and the license was eventually returned to the city.

4
PUBLIC RELATIONS

With controversy in Gardena about whether or not the card clubs should be allowed to continue their operations still fresh in the minds of voters, Primm also took notice of the close polls. It was clear to those concerned that something had to be done to improve the card clubs' public image.

Primm's public relations executive, Blaine Nicholson, proposed the concept of publishing a local magazine that would showcase the attributes of Gardena, featuring positive stories about what was happening in the city, insights into city council and profiles on prominent people in the community. The result was a publication called *Your Town*, a small informative monthly mailer that went out to the household of every registered voter in Gardena.

Your Town magazine was sponsored by the Rainbow and Monterey Clubs and printed on the presses at Nicholson's Gardena office. It included, among other things, draws for small appliances aimed at housewives and featured photos of the winners in the magazine. There were also features about kids and on councilmen and their involvement with community activities. But the magazine's main intention was to demystify the card clubs, offering readers a transparent view of how they operated and replacing their common perception as underworld organizations with a more positive image of the clubs as partners in the community.

As a bonus feature, the back of the magazine contained a coupon for the Gardena Fun Day Club that could be redeemed by families with children between the ages of six and twelve years old. The coupon would allow children, on their birthday month, to attend a joint birthday party

A High-stakes History

with other Gardena kids who shared birthdays that same month, all at the expense of the Rainbow and Monterey Clubs. Each month, the Gardena Fun Day Club would drive a birthday party bus full of Gardena kids to Disneyland completely free of charge. The clubs would lease buses from the Gardena Municipal Bus Line and hired staff from the city's recreation department to be chaperones for the day trips.

The publication proved to be a tremendous success, lasting for almost a decade. Nicholson recalled of the effort, "It was almost fifty percent of the people, when I did my first survey, that were against the card clubs in Gardena. But after ten years of doing public relations in the city, there was only one percent of the population that was against the clubs." *Your Town* is often cited as being one of the major catalysts responsible for turning the tide of public opinion.

Your Town magazine. Blaine Nicholson.

Originally from Arkansas, Nicholson came to Los Angeles in the early 1950s and worked for the advertising and public relations department of the May Company in downtown L.A. His introduction to Gardena came one day during a lunch hour after spotting a city bus with "Gardena" listed as the destination. Curious, he asked a co-worker, "Where's Gardena?" The man then told him about the town thirteen miles south along Vermont, where poker was legal.

Intrigued, Nicholson soon accepted a job in Gardena working as the advertising and public relations director for the *Gardena Tribune* newspaper, an occupation that educated Nicholson about the card club industry. After meeting Primm through political consultant Jim Cullen during the 1958 No. 1 and No. 2 campaign, Nicholson went on to produce advertising and entertainment for Primm's clubs in Gardena and Reno for over a decade.

On July 1, 1960, Roy Tracey was promoted to the post of Gardena chief of police, replacing Elmo Field, who had retired after twenty-two years in the position. Tracey, no stranger to the inner workings of the card clubs, found the biggest problem at that time to be the number of drunks trying

Gardena Fun Day coupon from *Your Town* magazine. *Blaine Nicholson.*

to get into the card games. As Tracey explained it, "All the clubs maintain their own security forces, and overall, we have no trouble from within the organizations. They co-operate fully on investigations and no attempts are made to cover up any crimes so far as I know."

One such security force was run by Sid Marks, security chief at the Gardena Club. Marks was born in Great Britain. At fifteen years old, Marks had lied about his age to enlist in the British navy during World War I. He suffered a leg injury in a major battle and soon after immigrated to Canada, forging a career as a professional lightweight boxer. Fighting out of Winnipeg, Canada, he boasted the unfortunate professional record of seven wins, thirty losses and five draws, having been knocked out a total of eighteen times. In his last professional fight, which took place in Havana, Cuba, in 1926, *Ring* magazine reported Marks went down from the first punch, and the fight lasted about "two seconds," with Marks being booed loudly by the angry crowd.

Marks later found a new career for himself in Hollywood, working as a bodyguard for actress Mae West. He was also a close friend of George Burns and Gracie Allen.

Ripley's Believe It or Not! featured Sid Marks in a cartoon about training World War II soldiers to fend off bayonets barehanded. During World War II, he and Joe Louis hosted training camps together, teaching troops the art of hand-to-hand combat. Marks's other claim to fame was that in 1953 he published *The Newspaper Boys' Hall of Fame*, a collection of photographs, autographs and biographical sketches featuring presidents, movie stars and captains of industry who were all, at one time in their youths, paperboys. Marks himself had been a paperboy in London's east end during the early 1900s. In 1973, the collection was donated to the Valley Forge Freedom Foundation.

A High-stakes History

Through his security work for the Gardena Club, Marks became a fixture in the community, telling the press, "We all have instructions to run clean clubs. We have no interest in how a player does at cards so long as he keeps his mind on cards and doesn't get out of line."

The Gardena Club was an unusual club, in that it catered to mostly elderly people. The club's biggest paydays came right after social security checks came out. It was also renowned for the interesting folks who played as regulars. Characters like the aptly nicknamed Time Clock Joe, who showed up at nine o'clock every morning and left exactly at noon. When he didn't show up one day, the club staff knew he was dead. Other notables included a comically foul-mouthed senior citizen known as Dirty Mouth Paula; and Sitting Bull, a woman who could sit at a poker table for impossible lengths of time without ever getting up to go to the bathroom. There were also some famous regular players, like Jack Rollins, who wrote the evergreen Christmas song "Frosty the Snowman," and Henry Buchalter, who was the son of Lepke Buchalter, the head of Murder Inc.

On one occasion at the Gardena Club, an armed robber burst in and held up the club cashier's cage. A brave boardman chased the robber outside and tackled him on the sidewalk. In the tussle, the gun fired and shot off

Gardena Club boardman. *City of Gardena Archives.*

89

Gardena Poker Clubs

Lots of polyester on display at the Gardena Club. *City of Gardena Archives.*

the robber's thumb. As the bloody bag of stolen cash scattered all over the street in the breeze of passing traffic, some of the club's more unscrupulous players came outside to see what was going on. Needless to say, the club never recovered any of the money.

A High-stakes History

The early 1960s was a new era for the Gardena card clubs. With operations running twenty hours a day, the city's six card clubs were collectively grossing $8.5 million a year and making up an estimated 25 percent of the city's operating budget. The city finally had a lock on the dozens of persons listed as shareholders in the clubs, with fingerprints and photographs on record in an effort to screen out known criminals. The going price for a single 1 percent share at that time was approximately $36,000, and with that investment, one could expect an annual return of nearly 10 percent. A list of powerful local businessmen, auto dealers and restaurant owners held shares in the clubs.

Notable owners of the time included Primm, Martin and John Lochhead of the Rainbow and Monterey Clubs (Lochhead was an owner of several California-based hotels and had bought an interest from Primm in 1961); Klassman of the Embassy Club, who now had an interest in legalizing card clubs in the Los Angeles suburb of Cudahy; Van Der Steen, a Beverly Hills–based financier; and Russ Miller of the Normandie Club.

The clubs still received all their gaming revenue from chair rental fees collected by attractive chip girls every half hour. Fees for the games varied. For instance, a fifty-cent game would run a player seventy cents an hour for his seat, whereas the chair fee for a ten-dollar game would be three dollars an hour. Prospective players would have their initials put up on a blackboard, indicating what level game they wanted, and then wait to be called by the boardman when the appropriate chair at one of thirty-five tables became available.

Chip girls would have the additional duty of changing a table's deck of cards every half hour, in an effort to prevent cheating. Cards would be scrutinized to ensure that players hadn't marked them. If a manager suspected a player of cheating, he would go upstairs into an attic area with a network of gangways above the gaming floor and use a periscope to peer down through a one-way peephole window for a closer view of the action. Typically, each table would have a spy hole in the ceiling above it scattered among the dozens of fire sprinkler heads. From those vantage points, club staff could sweep the room, looking for improprieties. The periscopes' magnification sometimes allowed surveillance teams to zoom in close enough to see the manicure on a player's fingernails.

The room would be scanned in search of cheats using any number of recognizable telltale moves, such as someone friendly pushing a stack of chips across the table to a lucky winner but with a sticky palm full of glue to steal back a few of the chips, a hold-out man keeping a good card from the last hand to use in the next one or a pair of crooks working

GARDENA POKER CLUBS

GARDENA'S SIX CARD CLUBS

The Monterey Club

The Horseshoe Club

The Normandie Club

The Rainbow Club

The Embassy Club

The Gardena Club

Interior of the Rainbow Restaurant

Lobby of the Normandie Club

Interior of the Monterey Restaurant

Interior of the Monterey Card Room

YOUR TOWN ILLUSTRATED Page 13

Your Town magazine card club illustrations, 1965. *City of Gardena Archives.*

92

as anonymous partners using secret signals at the table to cheat. Once a cheat was noticed and studied from the eye-in-the-sky above, the staff in the ceiling room would phone the floormen below to expose, for example, "Player Number Six at Table Twenty-Four." The floormen would then make note of the crooked player's face in order to bar him from any future entry to the club. A manager would discreetly get the cheat's attention from across the room, signaling to him by holding his nose (the universal sign for "You stink in here!"). Then, the manager would signal again, this time brushing his hand across his other arm (indicating "Get out. Don't ever come back."). The cheats all knew these signs well, as they most likely had already been banned from one club or another before coming in. "We don't make money when a player loses his. We charge him for the time he's here; the longer, the better. A card thief is the worst thing that can happen to a club," remarked one club manager.

Cheating offenses generally weren't prosecutable. The only time an arrest would be made was if the cheater wore some sort of concealed mechanical or electrical apparatus to aid in the act of concealing cards. Cheating devices like this were known as holdout machines. One such device, confiscated at the Normandie Club, was made out of dental tools. The cheater had rigged the elaborate mechanical device with wire levers that ran through his sleeve and down the leg of his pants. The device was controlled by his knee under the table. When the staff at the Normandie stripped the device off the man, they were amazed at its complexity, having never seen anything quite like it before. The bold cheater, who had obviously invested a tremendous amount of time and money into crafting the illegal device, begged the staff profusely to allow him to have it back, promising to go out of state and never return to Gardena again. The Millers decided to keep the device and eventually encased it in a picture frame as a preserved piece of the club's history.

One odd incident at the Gardena Club concerned a manager, who suspected a cheat on the gaming floor, and went up into the attic above to get a better look at the action. The attic catwalks were narrow wooden planks a few feet above the club's ceiling tiles. The manager lost his balance, and his foot crashed through a ceiling tile, leaving him exposed, dangling above the club's card tables. As debris fell onto the table below, the players, undeterred, dusted off the table and began to deal again. The cheat just got up and left.

The clubs, still fierce competitors, were now not only competing with each other for gamblers' dollars but also with racetracks, such as Hollywood Park, Santa Anita and Los Alamitos, and the constant draw of Las Vegas. Club

Holdout device confiscated from a card cheat by the Normandie Casino, framed on the wall of the club's upstairs apartment. *Max Votolato.*

owners would often complain, "Las Vegas is the real big competition. The big players go up there. It isn't uncommon for the players in a big game to jump up and say 'Let's go to Vegas.'"

Northern California, at the time, was home to more than four hundred small- to medium-sized card clubs. When California attorney general Stanley Mosk, a vocal opponent of card clubs who later served on the California Supreme Court, and Governor Edmond Brown lobbied the state's lawmakers to outlaw poker clubs throughout the state, the Northern California legislators balked. In order to gain their support for such a bill, it was determined that Brown and Mosk would have to prove it could work by demonstrating its passage on a smaller scale, revising it for only those counties with populations over four million people. This left only Los Angeles as the proving ground for the new bill, a measure that threatened to outlaw Gardena's card clubs.

The Gardena clubs had Supreme Court judge Gitelson rule in their favor that the new proposed law was unconstitutional. However, he ruled further

A High-stakes History

that he could not put aside a proposition already scheduled for an election. This forced the clubs to band together, with Nicholson, Parks and Amador waging an all-out countywide political campaign to ensure the industry's survival. Proposition E was placed on the November 1962 general election ballot but was defeated by a landslide vote of 1,202,942 to 734,549. After such a decisive victory, the state legislature and anti–card club groups were silenced once and for all. But that calm was interrupted at 1:30 a.m. on January 12, 1965, by the roar of gunfire.

Louis Koullapis, a seventy-year-old retired machinist and sometime poker player, was well known at the card clubs, mainly as a customer in the restaurants. A flashy dresser, Koullapis owned fourteen sports jackets and eleven pairs of shoes. He lived in a tiny rented room in Gardena on 153rd Street and was popular with the neighborhood kids, who affectionately called him "Pops." Somewhat of a loner, Koullapis was a divorcé, and his only known living relative was a brother in Greece, whom he had recently visited. Landlord Fannie Erdman and her husband, Sol, had come to know

Gardena Club interior, 1969. *City of Gardena Archives.*

him well in the two years he lived in their home, but during the second half of 1964, Koullapis had been diagnosed with cancer. The disease had a mind-altering effect on his personality. He was treated at several county hospitals and at one point even required the use of crutches. The Erdmans suspected he was suffering from cancer, but Koullapis always referred to his infirmity as "just a bad case of the gout."

As Koullapis's mental condition deteriorated, he began episodes of preaching to poker players from the sidelines of the gaming floor. The guards would have to come by and kindly ask him to move on. "This year I am going to die and before I do, I am going to take twenty or thirty people with me," Koullapis told one of the guards at the Rainbow on one such occasion—two days before the violence began. It's anyone's guess as to whether Koullapis actually had a dark side; he had no prior criminal record, and the remarks seemed uncharacteristic of the beloved old man whom the neighborhood kids sent get well cards to during his last stint in the hospital. Koullapis had responded to each of those thoughtful youngsters with Christmas cards containing dollar bills.

Others painted a different picture of Koullapis. Margaret "Marge" Demogenes, New England's sixth-ranked female tennis player and an acquaintance of Koullapis, said that he didn't like the card clubs and detested the evils of gambling. "But the card parlors were only part of it," recalled Demogenes. "He was loaded with viciousness for people in general. He had no friends. He hated the world. He hated America particularly." Card club patrons who had played with Koullapis indicated that the shooting may have been incited by his gambling losses. One thing was clear: Koullapis had been planning an attack for a long time, amassing a secret gun collection consisting of at least seven weapons, including a double-barreled shotgun, three automatic pistols and several revolvers.

As the action at the packed Rainbow Club was in full swing in the early hours that Tuesday morning, Koullapis's 1956 white Ford station wagon slowly pulled into the club's empty driveway and came to a stop, idling just outside the large plate-glass windows. The window curtains were closed, obscuring Koullapis's view of the 250 players inside the building. Koullapis got out of the car holding a double-barreled shotgun, aimed and fired two blasts, which ripped through the club's front door and a window. Next, he took out two automatic handguns, pointed them at the club's windows and fired at least sixteen shots at random, emptying his clips. Witnesses said that he switched guns several times during the attack, and bullets rained through the plate-glass windows, shattering glass, splintering wooden railings and

destroying the club's plush furnishings, as crowds of frantic patrons hit the floors and crouched behind the club's potted palm trees.

David Lee Whitmore, a security guard for the Rainbow, reacted at the first sound of shooting, running heroically out into the driveway, but he was quickly hit in the hip by gunfire. Another stray bullet struck a pedestrian outside the club. Inside, there was mass hysteria as the pre-dawn bloodbath was unfolding, with panicked patrons being hit indiscriminately by bullets and flying glass. For the people diving for cover under the large poker tables, crawling and slipping around on the card club's blood-soaked floor covered in glass, the five-minute attack must have seemed like an eternity. Voices all over the club screamed, "Get down! Get down!" As a lamp exploded by one of the windows, card player Bruce McNeil scrambled to get out of his seat. "I remember I'd just won a $25 pot, but I couldn't reach it on the table. I tried to tell someone to get my money but my throat was full of blood." McNeil had unknowingly been hit in the back and the side of his face by gunfire.

Others among the crowd of wounded patrons, completely caught off guard, included Howard Elgort from Burbank, who recalled, "I thought it was light bulbs popping at first. Then I realized it was shots and I hit the deck. When I got up later, somebody said 'Hey, you got blood on you.' I was hit five times by shotgun pellets." Seventy-four-year-old Arthur Adrian Archibald, also a Burbank resident, was not as lucky, being left in critical condition after one of the bullets tore through his kidneys. Archibald later died of his injuries, the only fatality from the attack.

Gardena police officer Ruben Davis, who lived in a house adjacent to the Rainbow Club's parking lot, heard the heavy gunfire from his bedroom and immediately called the police station, reporting, "It sounds like a war going on at the Rainbow Club!"

Nobody inside could see Koullapis as he sprayed gunfire into the club; their view of the driveway was also blocked by the draperied windows. When the shooting stopped, people rushed to the doors and witnessed the old white station wagon careening across the parking lot toward the adjacent Monterey Club. While patrons anxiously jotted down the grey-haired shooter's license plate number, Koullapis pulled over, firing shots into the Monterey Club, striking two people inside.

Koullapis climbed back into the station wagon and screeched out of the parking lot into the southbound lanes of Vermont Avenue. He headed for the Horseshoe Club half a mile south and fired once through a window. Fortunately, nobody inside was hurt. From there, Koullapis sped off into

Gardena Poker Clubs

A view of the Rainbow, Monterey and Horseshoe Clubs looking south along Vermont Avenue, 1968. *City of Gardena Archives.*

the night. A massive police search had already begun, with officers armed with a description and license plate number fanning out across the city. An ambulance rescue was also underway, as paramedics transported the many wounded to local area hospitals.

After only a few minutes of searching, Gardena police officers Louis Purcell and Donald Williams discovered the white station wagon abandoned with the engine still running. As they approached the vehicle and matched the license plate number, Koullapis, who had been hiding nearby, walked toward them holding two pistols pointed skyward. He pulled the triggers three times, but the guns were finally empty.

Officer Louis Purcell later told the press:

> *We didn't drop him. Lord knows, we had reason to. We covered him with our weapons. We didn't want to shoot him. He was mumbling incoherently and it was necessary to fire two shots at his feet. We got the guy's attention. He stopped. We looked at him. We were then close enough to attack. We had to fight him and disarm him.*

A High-stakes History

Koullapis was wrestled to the ground and suffered a broken collarbone in the struggle. He was booked and taken to Los Angeles County General Hospital to be treated in the prison ward.

As the gun smoke cleared, Koullapis's motives became more clear when police searched his ten-dollar-a-week rented room and found—in addition to a half-empty pint of whiskey and a paperback copy of the biblical novel *The Greatest Story Ever Told*—the remnants of three drafts of a suicide note, apparently written to the popular Los Angeles television newscaster Jerry Dunphy. The unsigned suicide notes (one was written in Greek) were scrawled in his broken English:

> *Dear Jerry,*
> *What I am doing tonight. It should be don* [sic] *long time ago but never too late. Better late than never. It could save a lot of innocent and good people.*
>
> *These gyps* [sic] *joints destroyed lots of homes. Thousands* [sic] *of divorce and good many thousands of children are without father or mother. The crimes are increasing at least 100%.*
>
> *Many young women became prostitute just to have money to play cards. Isn't that enough. Couldn't the law see to that.*
>
> *Tonight I am sacrificing my life just to see if they will be close forever. I am old and very sick man. I lived my life already. Is nothing left for me in this world.*
>
> *Close them, close them, close them at once. The only thing bothers me I am going to hurt innocents* [sic] *and passing by people, but I have no choise* [sic].

Charges against Koullapis were filed in South Bay Municipal Court, where he was accused of maliciously discharging a firearm in an occupied building and charged with murder and attempted murder. In addition to the single fatality, Koullapis had left behind twenty-six wounded victims. In May 1965, he was found guilty of second-degree murder and sentenced to five years to life imprisonment. Koullapis died of a heart attack in 1968 while serving out his sentence at the California Men's Colony in San Luis Obispo.

Koullapis's gunshots, though intended to destroy the Gardena poker industry once and for all, had little effect on the clubs' bottom lines and, in reality, halted business only slightly longer than it took for the uninjured players to climb off the floor and shake the glass out of their hair. Card games resumed as paramedics wheeled out the injured.

After a 1966 lawsuit for unpaid loans bankrupted Klassman, he left the Gardena scene, and the defunct Embassy Club was bought

by Beverly Hills businessman Warren Blank. Years of neglect had left the Embassy Club in disrepair, and Blank embarked on an extensive renovation project, converting the old California Art Deco building into a glamourous Spanish Colonial Revival–style structure. The luxurious re-stuccoed and re-roofed twenty-nine-thousand-square-foot club sat on 6.7 acres and featured porticos and sophisticated topiary landscaping. It was rechristened the Eldorado Club.

When an improperly administered medical test left him unable to speak for three years, Blank sold his interest in the club to George Anthony and his four brothers in 1968. Anthony's corporation, Ver-Don Inc., was an obvious ode to the Ver-Crans Corporation dismantled by the Kefauver committee, referencing the Eldorado's location on the corner of Vermont Avenue and Redondo Beach Boulevard.

Born in Kansas City, Missouri, to Lebanese parents, and the eldest of five boys and two girls, Anthony learned much of his trade from his father. At various times, he and his brothers had owned a bowling alley, a restaurant, a mini-golf course, an appliance repair business and a catering company.

Anthony, a former master sergeant in the U.S. Army Corps of Engineers during World War II, held a number of patents, including one for a simulator

The Eldorado Club. *City of Gardena Archives.*

used in antimissile warning sites. At the time he entered the Gardena card club business, he also owned a refrigeration company in nearby Inglewood, holding a patent on one of the first commercial freeze-dry units in the nation. One of his inventions, a steam engine–powered car, stood on display in the back of the Eldorado. Anthony's patented technology for a tape machine that played four hundred hours of continuous music was eventually used in a device sold by national retailers, including Kmart and JCPenney.

As the 1960s came to a close, the departure of Klassman and the death of Van Der Steen in 1968 left behind a new hierarchy in the circle of Gardena card club owners. Joe Hall rejoined the Normandie Club and partnered with Russ Miller; Bow Herbert still owned the Horseshoe and Gardena Clubs; George Anthony was the new owner of the Eldorado Club; and the godfather of Gardena poker, Primm, was still at the helm of the Rainbow and Monterey Clubs.

5

THE POKER CAPITAL OF THE WORLD

Gardena's early 1970s political landscape had become transparent about the financial influence of the clubs in city elections. With sixteen thousand registered voters in Gardena, there were more political campaign lawn signs on display than in any other South Bay city and more campaign dollars at work than in any other Southern California municipality.

When Ken Nakaoka was appointed mayor of Gardena by the city council in 1968, he became the first Japanese American to head a municipal government in the country. A realtor by trade, Nakaoka had been elected as a councilman in 1966, becoming the first Nisei to ever win a council seat. Nakaoka also was elected mayor by the voters of Gardena in 1972.

It was widely known that Primm had donated to the campaigns of Nakaoka (please note Nakaoka was not supported by card clubs in the races of 1970 and 1972) and Councilmembers William Cox and Don Dear. The Normandie Club donated to Robert Kane's last campaign, with public relations officer Charles Amador designing his brochures. Both Herbert and the Anthony family had donated to Edmond Russ's campaign. These contributions were all perfectly legal and listed with the city clerk's office, as required by law.

Russ speculated at the time that the card clubs were responsible for pumping at least $40,000 into municipal elections. He challenged that competing interests from the clubs were creating an unbalanced electorate in Gardena, pointing his finger at Primm as the biggest culprit: "Primm

A High-stakes History

Gardena Card Clubs — Frequented by People from All Over the World

You haven't really seen Southern California until you've visited Gardena, Poker Capital of the World.

Experience the thrill of playing in the elegant surroundings of some of the world's most famous card clubs. Whether you come to play or to enjoy the outstanding cuisine in one of the clubs' renowned restaurants, you will enjoy the Gardena experience.

Gardena clubs are frequented by people from all over the world. *City of Gardena Archives.*

wants to control things. The card clubs are in Gardena legally. They are legitimate businesses but like the liquor industry they must be regulated."

The political influence being asserted on the city was a result of the fierce competition that existed between the clubs. In the new age of card club politics, political alliances could be leveraged effectively to provide advantages for one club owner over another.

During the summer of 1972, the city council altered the ordinance repealing the mandatory staggered closing days, and fears emerged that

Primm's lucrative clubs would draw even more business away from the smaller clubs, putting them out of business by operating seven days a week. Albert Pearlson, attorney for the Horseshoe and Gardena Clubs, appealed to the city council that the Gardena Club's business was already on the ropes and net profits for the club were down 50 percent from the prior year.

Pearlson and others were right to be paranoid about the change. Primm had been making attempts to starve out the competition for some time, kicking off the assault by using Councilman Cox to propose the idea of closing all the clubs on Sundays under the grounds of a blue law. Cox tried to sell it on moral grounds but the proposal was quickly defeated. Eldorado Club owner George Anthony fought vigorously against the seven-day rule, submitting a petition on behalf of the Eldorado, Gardena, Horseshoe and Normandie Clubs, backing a repeal of the new law with 3,024 signatures of support. He argued that there wasn't enough business to support six clubs all being open on the same days.

By late January 1973, the city council relented under pressure that the seven-day opening was mainly to the benefit of Primm and the detriment of the other clubs, reenacting the staggered closing days. However, when it was decided that the Monterey and Rainbow Clubs would be allowed to close on separate days, effectively allowing Primm to operate at least one of his clubs every day of the week, the other club owners cried foul. Jack Tenner, attorney for the Normandie and Eldorado Clubs, argued to the council, "You're doing this at the request of Ernie Primm, and his associates. I'm going to the grand jury to ask for an investigation into the relationship between Primm and the council. Whenever Primm says to jump, the council asks: how high?"

An advertisement for the Horseshoe and Gardena Clubs. *City of Gardena Archives.*

A High-stakes History

As George Anthony announced plans to circulate another petition to stop what he asserted was "the influence of Ernie Primm on a legal industry," another problem loomed high above Rosecrans Avenue: a gigantic billboard beckoned drivers to "Draw the Winning Pair" in an advertisement for the Rainbow and Monterey Clubs. The billboard, which sat atop a building near Rosecrans and Vermont Avenues, was so large that at a certain time of day it cast a shadow across the Horseshoe Club.

Incensed by the blatant disregard for the club owners' agreement not to build up a mass of sidewalk signs, Herbert's attorney, Albert Pearlson, urged the council to force Primm to remove the sign before Vermont Avenue was turned into a billboard jungle in retaliation. "What do you want us to do? We could hire the Goodyear blimp and have it go up and down Vermont Avenue to advertise our clubs. Do you want that?" Pearlson reasoned.

In an attempt to return some harmony to the circle of club owners, Mayor Nakaoka put together a private party, inviting all the owners to meet with him as a group without the aid of the city council. Don Dear was the only councilman to join the gathering. The end result was a slightly clearer air around the group, but apart from everyone agreeing that the party was fun and Mayor Nakaoka was a great host, little was done to resolve the outstanding issues.

In late February, George Anthony presented a petition with 2,735 signatures calling for the council to abolish the current ordinance allowing the Monterey and Rainbow to be closed on separate days and let the people vote on the issue of closing days. And on May 29, the city's voters chose Proposition D, opting to return Gardena to the original staggered closing day schedule the clubs had used for the previous decade, meaning that Primm's clubs would now be shut on the same day.

The Normandie and Eldorado Clubs distributed a circular titled "Gardena's Civic Cancer" in advance of the election, urging voters to choose Proposition D, resulting in Mayor Nakaoka launching two unsuccessful lawsuits against both clubs. The first contended that the "Gardena's Civic Cancer" mailings were illegal because they didn't declare their financial sources, and the second was a defamation of character suit against the two clubs and public relations man Charles Amador for $500,000 apiece, alleging that the clubs, through their publication, had tied him and other members of the council to underworld organized crime figures by suggesting that some card club affiliates were "hoodlums" pulling the strings at city hall.

Nakaoka was unseated by Edmond Russ in the 1974 mayoral race. Russ had been mayor once before in 1969, and this time, he put together heavy

finances to ensure his success at the polls, spending $18,000 of his own money. But it was the Gardena Better Government Committee, an entity set up by the Normandie and Eldorado Clubs, that really tipped the scales against Nakaoka, pouring $35,000 into Russ's campaign to defeat Nakaoka and two other incumbents. The move was so bold that the following year a law was enacted to prevent individual campaign donations exceeding $500.

During the fall of 1973, the rumble of support in the clubs for the introduction of panguingue was reaching fever pitch. Known as "pan" for short, the rummy-style card game's objective is to be the first player to lay eleven cards face up on the table in valid melds. The council held a two-hour hearing on the subject, which drew a crowd of one hundred people to listen to a united appeal from the owners. With three council posts—as well as the position of mayor—up for election again the following April, tensions over licensing the new game ran high among the politicians fearing a reprisal at the polls in 1974.

The council listened anxiously as Tom Parks, public relations director for the Horseshoe and Gardena Clubs, explained statistics from the state of Nevada showing that panguingue generated 178 percent more revenue than poker. Every club wanted to convert five tables of their thirty-five-table allowance over to panguingue. A special report on the game indicated it was already played legally throughout California and attracting more affluent players than traditional poker. One example cited a one-thousand-member club from Beverly Hills that played panguingue in private residences.

Local clergymen—Reverend Arthur French III of the First Presbyterian Church and Reverend Earl Keester of Calvary Baptist Church—came out in opposition to the new game. Reverend French argued that the city would have to draw a line in the sand or risk being overrun with future requests to bend the ordinance, stating, "I can see the appeal for fifty slot machines so those waiting in line to play pan won't have idle hands. Then will come the dice tables. Remember, once 'Yes' is said, where do you say 'No'?" But by the end of the year, in an effort to help boost card club revenue, the city council voted 3–2 in favor of licensing the new game.

After the death of Bow Herbert in 1973, the Horseshoe Club continued to flourish. It was different from the other clubs in the sense that it attracted a younger and more affluent crowd. The club hosted players like Bill Roberts, who was a partner with Stuart Spencer, and handled political campaigns for Ronald Reagan for governor and president. John Holmes, the famous porn star who later died of AIDS, was also a regular. Ruth Handler, president of the toy company Mattel and inventor of the Barbie

A High-stakes History

Aerial shot of the Horseshoe Club. *City of Gardena Archives.*

doll, also came in a couple of times a week in her Rolls-Royce and was considered a good player.

One night, actor Gabe Kaplan, famous for his role as a high school teacher on the sitcom *Welcome Back, Kotter*, came in and wanted to cash a $10,000 paycheck. Not recognizing the television star, the club's cashier turned him down, saying she couldn't cash the check because she didn't have his credentials on file. When Kaplan went over to the Eldorado, George Anthony happily cashed the check, thereby locking him in as a regular customer. Kaplan went on to be considered one of poker's elite, winning the main event at Amarillo Slim's Super Bowl of Poker in 1980.

For Gardena native and former Normandie Club employee Paul Greco, who spent nine years working at the club, in the 1970s and early 1980s, poker was the family business, with his brother and sister-in-law's family all employed by Gardena card clubs. Greco grew up around the Gardena poker culture. His father, a truck driver for Dr. Pepper and Squirt on Redondo Beach Boulevard, and his mother, a Gardena cocktail waitress, were locals who often hosted seven-card stud poker games at their dining room table. He learned the game as a child, playing penny ante poker with his aunts and grandmother.

In 1973, Greco went to work at the Normandie Club, starting as a boardman and eventually working his way up to floorman, earning $400 a day. Early on, he caught the attention of club owner Joe Hall, who was now in his seventies. "He made me his personal driver," recalled Greco. Hall lived in Century City, and Greco took on the duty of driving him to the Normandie Club every morning before starting work at the board. "Every morning he would make sure that I brought him $320 and he would start the games. He was a regular gambler. He loved to play cards and he hated to lose."

During those long drives across town, Hall told Greco stories about his early roots in the business, including one tale about his dealings in the late 1940s, when he had owned a piece of every gambling boat off the coast of Southern California. Another story detailed Hall's partnership in the old Embassy Club, explaining how he came into the operation as a "plumber." A bemused Greco replied, "What d'you mean as a plumber, Joe? You're not a plumber." Hall smiled knowingly. "What d'you mean? I fixed the leaks!" As Greco later explained, the position strictly involved managing the efficiencies of the business: "A 'plumber' is an old expression where you come into a casino and fix where the money is leaking out the door—not the actual plumbing! And you know, [at the time] a stupid punk like me, wouldn't know the difference."

The two men cultivated a special friendship, and Greco spoke fondly of Hall, describing him as the "truest gambling extraordinaire that I ever met in my life," continuing:

> *He knew everything about the poker business, about cards, and about action. Joe Hall was the kind of guy that when he'd see a guy on the rail broke and he knew his face, he wanted him in the game. He'd always come up and give him twenty dollars or fifty dollars and get him off the rail. There were no other owners, that I know of, that ever did that in the Gardena card clubs.*

Never the type to wear a suit and tie, Hall was considerably groovier and would often be seen in a pair of perfectly pressed slacks and a Pendleton shirt with flap pockets. Before Hall died in his eighties, he married Joan Boyd, a former Las Vegas performer and the ex-wife of big band leader Harry James. According to Greco, "I don't think Joe ever had a wife before that. But he had to have a trophy wife."

In comparison, Hall's partner, Russ Miller, was an equally magnetic character in his own right. Known to be an incredibly warm people person who was loved by his employees, Miller knew everyone's name and always

shook hands. He had a knack for keeping employees long term, some as long as forty years. People who worked for him felt like they were part of the family, and because he had started from the bottom, Miller afforded everyone who worked for him the opportunity to rise through the ranks, frequently promoting from within the organization.

Greco recalled the Miller family patriarch's warm demeanor:

> *I remember going up to his house, and he treated people good, old Mr. Miller. He lived up in the Palisades. He was slow walking. Easy going. Never cared about poker or anything. Never cared about the card room per se. You'd never see him on the floor. You'd see him in the restaurant. Or you'd see him hanging around close to the window, where the money was.*

Miller, whose neighbors in Pacific Palisades were Brooke Shields and the actress Goldie Hawn, was known for spreading goodwill and treating people well. He could be equally good humored and merciful when dealing with cheaters caught in the club, escorting them out with a tongue-in-cheek warning never to come back or they would run the risk of being taken out to the valley on a windy night.

The Normandie Club definitely had its share of cheaters in the 1970s. Longtime employee Barbara Leslie-Laretto recalled an incident in which she once watched a player, who was dealing for the table, rifle through a deck of cards and pick out all the ones he wanted. "He had like ten or twelve cards in his hand. And I hollered at the floorman, I said 'I don't think this is right.' We watched him and he lost the hand. I mean this is how bad of a cheater he was. He lost the hand!"

Most such improprieties were possible because there were no house dealers. Years later, when house dealers were introduced, the players were more protected from the danger of cheaters. To compensate, the decks of cards were routinely switched and cleaned to prevent cheaters from marking them.

Working at the Normandie exposed Greco to a host of colorful characters. He recalled his encounters with a couple of redneck brothers, Jimmy and Bobby from Fresno, who had created an art form out of their cheating. "They were something else. They were exciting. They were young. They were like my age. And they were good!"

Greco's boss, Harold Smith, had warned him to be on the lookout for players wearing cowboy boots. The thought behind this was that the clubs were being targeted by gypsy clans of cheaters from Fresno and Oklahoma.

Cowboy boots would be a telltale sign, and nine out of ten times, a customer wearing cowboy boots was up to something. "Pretty soon after that, we were all wearing cowboy boots," laughed Greco. In the era of mid-1970s crossover country music stars like Kenny Rogers and Willie Nelson, cowboy boots had become a popular urban fashion statement.

Before long, the cheating brothers were caught and barred from the Normandie. With their names and faces now on file, they disappeared from the scene. "Everybody knew who they were. Now the next year they come back and they walk in the door and they're dressed like women," said Greco. "Next day, I see them come in again dressed in drag. They looked good, too. They were playing a big game as two girls and nobody could tell the difference."

Mass cheating and a climate of constant suspicion meant that arguments and fights were commonplace among patrons. Chip girls carrying heavy trays of food and beverages to the card tables had to be quick-witted to avoid these altercations. The heavy trays could often cause painful injuries when knocked over by brawling players.

Inside the clubs, patrons were served a steady stream of cigarettes, food and beverages (mostly coffee and Coca-Cola). All food and beverages had to be purchased, as the clubs were forbidden to influence patronage by giving away freebies. These ordinances were so strict that clubs couldn't even give away a cup of coffee, ensuring that everything was always equal.

There were bars within walking distance of all the card clubs because they weren't licensed to serve liquor at that time. Local bars like the Four Queens, the Iron Lantern (which later became the Midway Bar), the King's Inn and Gordies always did great business generated from card players and card club employees. There was a lot of nightlife.

The "no alcohol" policy was so strict that, in order to get a drink during their gameplay, players would often have to get their timing down to a science. Greco recalled watching a Normandie regular, golf pro Ray Mangurum (older brother of the more famous golfer Lloyd Mangurum), making trips to the bar across the street between betting rounds. "He'd make it across Western Avenue, take a shot and walk back, sit back down in the seat and never miss a hand."

Prostitution and a prevalent drug scene were also fixtures outside the card clubs and in local bars. "[You didn't see it in the card clubs], it was outside with the pimps and in the bars." Greco recalled the 1970s drug culture being very separate from the card clubs: "The card club people were straight. They were doctors and lawyers. These are regular hustlers and gamblers. You didn't see no drug people in there."

A High-stakes History

An inside view of the Gardena Club. This photo was featured in an issue of *Westways* magazine, published by the Automobile Club of Southern California in the early 1970s. *City of Gardena Archives.*

A countrywide investigation into the mysterious disappearance of Jimmy Hoffa, the former International Brotherhood of Teamsters president, took place during the summer of 1975, after Hoffa vanished from the Machus Red Fox Restaurant parking lot in suburban Detroit in late July. That August, FBI agents stormed the Eldorado Club, questioning George Anthony about Hoffa's whereabouts. Anthony had known Hoffa since the early 1960s and, according to his brother, David Anthony, had recently met with Hoffa to negotiate a loan for building a new hotel at the Eldorado Club property. Although the club received some funding from the Teamsters, David Anthony insisted, "We didn't want to deal with Hoffa's union. George was a very honest man. It was against the grain of our family to go to Hoffa."

More sinister rumors circled that during the 1970s the Teamsters paid kickbacks to Anthony and he was somehow involved in the disposal of Hoffa's body in return for financing for his Eldorado hotel project. The fact that the hotel was never realized gave little credence to these rumors. Anthony, at times thought to be very egocentric by his competitors for putting an image of his face on the Eldorado Club's fifty-dollar poker chips, had a wry sense of humor.

*Relax and Enjoy Yourself at Gardena's
Most Luxurious, Hospitable Card Club*

- Only 10 minutes from International Airport — 15 minutes from downtown Los Angeles
- Hospitality and atmosphere provide a memorable evening for local residents and travellers alike
- Luxurious, air conditioned card room
- Open 9:00 AM to 6:00 AM
- Fine dining at reasonable prices in the Eldorado Restaurant, Buffet and Coffee Shop

Eldorado Club

15411 Vermont Avenue, Gardena, California 90247 • "Corner Redondo Beach and Vermont - 323-2800"

Eldorado Club ad. *City of Gardena Archives.*

According to David Anthony, the whole Hoffa episode started as a joke. George had been upstairs in the Eldorado's VIP room one Saturday night in early August, and when he returned downstairs to the club, someone on the gaming floor asked him, "Hey, George, who do you have up there?" George

gave a deadpan answer: "Jimmy Hoffa." The FBI arrived three days later. Anthony hardly ever spoke about the Hoffa incident again, except on one occasion when it was rumored that, while walking through the Eldorado, he stopped and patted a cement post, jokingly saying, "Hi, Jimmy."

For the Primms, success was mixed with misfortune. In 1966, Evelyn Primm was seriously injured in a sailplane accident in an attempt to log enough miles to qualify for the National Soaring Championships in Reno. According to Ernie, Evelyn's injuries were so bad that her doctors had considered amputating her leg but he brought in seven specialists, who managed to save her from the procedure. In addition to her many trapshooting titles, Evelyn was the one-time holder of the Nevada women's sailplane altitude record of 32,600 feet.

Yet Evelyn continued her life as a celebrated socialite, even attending a party at the Palette Club of Palm Springs that was covered in an article. It mentioned that Evelyn's foot was still healing nearly a year after the accident. But their hectic celebrity status took its toll, and the Primms' glamorous marriage ended with a divorce in 1973. After years of pain following her sailplane accident, Evelyn Primm took her life at home in Palm Springs in 1975.

By the bicentennial summer of 1976, Primm's eldest son, thirty-six-year-old Gary, had become a general partner and general manager of the Rainbow and Monterey Clubs. The athletic young man with a black belt in karate and a love for speed racing was now being groomed as an executive and heir to the family poker empire. After graduating from San Marino High School, Gary had gone on to study at the University of New Mexico and earn a bachelor's degree in business administration at the University of Southern California.

But it was Gary's fascination with engines that really drove him, having spent much of his youth building sophisticated racing boat engines in his own workshop. Gary and his partner, Newt Withers, held the world speed record in the K runabout class for a measured 5.8 miles. During the 1975 Kilo Runs in Parker, Arizona, Mike Brendel drove the new Withers and Primm Special K boat for runs of 142.120 miles per hour, 141.045 miles per hour and 141.580 miles per hour. Gary built the Hondo "Spirit" boat's custom engine using a blown Chevy engine powered by straight alcohol. He remarked of the event, "There is a tremendous reward and deep satisfaction from creating an engine to perform to certain requirements and specifications."

Gary was less successful when it came to his love of racing cars. Having been involved with drag racing since he was sixteen years old, his ambitions

took him to Mexico to compete in the Baja 1000 alongside racing greats Parnelli Jones, Ray Brock and Mickey Thompson. But Gary and Newt Withers broke down two hundred miles out and never finished the race.

Gary's early business career included stints in the meatpacking business at Swift & Company in Vernon and as a salesman for Davidson Chudoff Meat Company. This led to him starting up his own enterprise, the Primm Meat Company. Soon, the family business beckoned, with Gary initially working on the Rainbow and Monterey Clubs' monthly magazine *Your Town*, before going on to work in every facet of the clubs in order to learn the business from the ground up. Later, he became a member of the board of directors for the Gardena Chamber of Commerce and the chairman of the Gardena Card Club Association, a group comprising club owners and general managers.

Ernie Primm had sold the Primadonna and its surrounding Reno properties in 1974 to the Del Webb Corporation for $5.5 million. With the Rainbow and Monterey Clubs being managed by his son Gary, he decided to retire but quickly grew tired of doing nothing. It was time to go back to work, and in 1977, Primm headed to State Line to do it all one more time, establishing the Whisky Pete's hotel and casino, named after the property's original owner, Pete MacIntyre.

Blaine Nicholson recalled visiting the dusty desert town with Primm:

> *He visualized that as a casino area. Originally, he thought that if they put the clubs out of business in Gardena, that maybe he could transport customers, from an L.A. airport to the California side of the border....The plane would let the people off and they could walk across the state line and go to the casinos....That never developed. But I used to go out there with him, and we'd stand there in that desert and he would say "What in the world am I gonna do with this?"*

In order to get things going in those early days, Primm would pay bus drivers to stop at Whisky Pete's and inform their passengers that the bus had engine trouble. Displaced passengers would then pile off the bus and into the casino to gamble while they waited for the next bus ride.

By the summer of 1977, the Gardena card club empire was on the verge of change. It started with a meeting at the Cockatoo Inn in Hawthorne between George Anthony and attorney Donald Cadoo, a major proponent for legalizing poker in Inglewood. The meeting was arranged by state senator Curtis Tucker, a Democrat who had been Inglewood's

first black city councilman and an early advocate for bringing poker to Inglewood. Tucker thought it could be useful for Cadoo and Anthony to meet face-to-face and understand each other's position. Anthony, a huge opponent of any competing card club initiative, especially one outside of Gardena, explained to Cadoo that in addition to the competition faced by a potential Inglewood card club, he also feared that if the venue was not run up to the high standards of Gardena, it could be detrimental for the whole local industry.

At the end of the meeting, both sides seemed puzzled about why they had been brought together. "All I know is it cost me $20. I picked up the tab," quipped Anthony. However, by the spring of 1978, his intentions came into focus when the Eldorado operator pledged to "Stand Good" for a $9,000 loan to the anti-poker group the Committee to Defeat Proposition A in Inglewood. Proposition A was a measure that would allow the City of Inglewood to license and regulate up to four card clubs. The Rainbow and Monterey Clubs also pledged $10,000 toward the Inglewood anti-poker initiative, and with outside pressure from anti-poker groups—such as the Inglewood Coalition Against Organized Crime, Citizens Against Poker Clubs and local church groups—spouting fears about how card clubs would "lead to the moral decay of the city," Proposition A was defeated.

This victory should have been very reassuring to the City of Gardena, as Inglewood's poker initiative was a close call. After all, by this time, Gardena's poker monopoly was accounting for $3.5 million of the city's $14.2 million budget, providing nearly $0.25 of every $1.00 of city income. Gardena's finance director, Keith Bennett, told the *Los Angeles Times*, "There is nothing in our city that approaches what the card clubs bring in. That goes for any segment of business." But it was this level of unhealthy dependence on one single industry that set the stage for a massive storm.

6
DEATH OF THE CARD CLUBS

By the time of Ernie Primm's death in August 1981, the Whisky Pete's hotel and casino had expanded to ten times its original size. But those close to Primm knew it was always Gardena that was his first love. Primm hated to lose, and in Gardena, he had always enjoyed the constant risk-free stream of revenue earned by simply renting players their seats. One time at the Primadonna in Reno, some lucky patron walked away from a keno game with $12,500. Afterward, Primm went around the casino, tearing down every sign promoting the game. Primm's death was symbolic in that it signaled the beginning of the end for Gardena's card club monopoly.

For years, the citizens of Gardena had enjoyed stable property tax rates that were offset by the clubs' revenues, and in 1978, Gardena's property tax rate was $1.01 for each $100.00 of assessed value. But in other cities throughout California, many homeowners were struggling with the financial burden of rising property taxes. The problem particularly affected retired Californians. Many living on fixed incomes were experiencing increasing difficulty paying property taxes on homes purchased decades earlier, which now faced severe inflation rates in their reassessments. With no cap in sight, many decided they could no longer afford their homes and were forced to sell.

It was this situation that prompted the state's lawmakers to enact Proposition 13, officially named the People's Initiative to Limit Property Taxation. And on June 6, 1978, California voters approved Prop. 13 with 62.6 percent of the vote, returning statewide property tax assessments to

The Eldorado Club
15411 S. Vermont Ave.
Restaurant—Poker
213-323-2800

The New Gardena Club
15446 S. Western Ave.
Restaurant—Poker—Pan
213-323-7301

The Horseshoe Club
14305 S. Vermont Ave.
Restaurant—Poker
213-323-7520

The Normandie Club
1045 W. Rosecrans Ave.
Restaurant—Poker
213-515-1466

The Rainbow Club
13915 S. Vermont Ave.
Restaurant—Poker—Pan
213-323-8150

Gardena down to five clubs. *City of Gardena Archives.*

their 1975 values and restricting annual increases to an inflation factor of no more than 2 percent.

After the passage of Prop. 13, cities throughout the state began to seek out new sources of revenue to supplement funds lost from the reduction of property taxes. Many cities began to explore the idea of licensing card clubs. Bell, California, a 2.6-square-mile municipality located in the industrial heartland of southeast Los Angeles County that made national headlines in 2010 over a city hall corruption scandal, was the first city to do so. In 1980, the plush seventy-table California Bell Club opened, giving Gardena card clubs strong competition from within the county.

The first casualty came in December 1980, when the Monterey Club, experiencing a 34 percent decline in revenue, closed down, leaving Gardena with only five active clubs. At the time, the club announced that it was closing temporarily for repairs and remodeling, but the doors never reopened.

Tom Parks recalled the turmoil caused by the opening of the California Bell Club:

> *The clubs in Gardena really had a tough time when the Bell club first opened because we were restricted. We could only have $20 limit games. We were only allowed 35 tables. We couldn't have liquor on the premises. None of those things. And then the Bell club opened and they could do just about anything they wanted. And the customers flocked to them—they left us. And I could understand why. We had treated them like a bunch of cattle before because we had our own way and there was no place else to go.*

Carlos Weitz, a fifty-eight-year-old regular at the California Bell Club, compared it with its Gardena counterparts, saying, "I think this is a lot better because of security. They've got a reputation down there [Gardena] for

Gardena Poker Clubs

Eddie Cieslinski watching surveillance monitors at the Gardena Club showing live video of games in process down on the floor. *City of Gardena Archives.*

having sharp people. There's a lot of robberies. Here security is good, which is important for senior citizens."

Cheating was still a chronic problem at all of the Gardena clubs, and as the technology designed to detect cheating grew more sophisticated, so did the cons. The card clubs' eye-in-the-sky systems had evolved from telescopes to closed-circuit television cameras, replacing the surveillance men on the gangways hidden above the gaming floor with a camera operator in a booth watching live images of players on a bank of television monitors.

One long-standing problem was players who tried to avoid paying their collection fees, which were due when the red light came on every thirty minutes. The rule was that you had to pay a fee to stay in your seat at the table. Players attempting to dodge the fee would get up and try to move around the room to avoid the chip girls taking collections. This gave club floor people and managers the additional duty of having to track the players, keeping note of where everyone was sitting to make sure they didn't get out of paying their fees.

The biggest worry clubs had was with cheating partners—where two or three players colluded in a game played with other unsuspecting regular customers whom they would work to sucker. Cheating partners would use

secret oral or physical signals to tell each other what kind of cards they were holding in order to win. Later on, they would meet outside the club and split the winnings. As Parks recalled, "They were always changing the signals. We knew who they were, but it was tough catching them and proving it."

According to Parks, the managers, who were well versed at spotting scams, would sometimes bring in reinforcements in the form of experts from the Magic Castle (Hollywood's academy of magical arts) to help detect cheaters. This would be for cases where, for example, the cheater used a holdout mechanism (a mechanical device used for the purpose of surreptitiously switching or retaining cards) or slick sleeves (a long sleeve on a clothing garment used to assist in holding out a playing card; sometimes they used mohair sleeves or little plastic surfboard-shaped card holders to hang on to better cards).

On one occasion, John Lochhead, manager and operator of the Monterey Club, came across a paper schedule left behind by a gang of three cheaters who played as secret partners in the 5 and 10 lowball game. The schedule stipulated what signals the cheaters would use in the games and where and when they would meet afterward to split the money. Parks, who had been elected general partner of the Rainbow Club after the Monterey folded, barred the three cheaters. But they fought back and sued the club for violating their civil rights. Oddly enough, they won the case. According to Parks, "The damn insurance company settled with them." As part of the settlement, the cheaters were allowed to come back to the Rainbow Club. A couple of them never showed up again, but one guy did.

One night, Parks, still scorned from the legal backfire, recognized the cheat, who was now back playing at one of the tables, and decided to administer his own form of justice: "I let the players at the table know who they were playing with. That was the last I saw of him. And I probably shouldn't have done that. After all, I probably could've got in trouble. But I couldn't help it."

The most ironic twist to the story came just a couple of years later, during the fall of 1983, when George Anthony, acting as chairman of the Gardena Card Clubs Association, got all the club owners to participate in a joint giveaway promotion in which the first prize was a brand-new convertible Chrysler LeBaron. "We had all the clubs selling the tickets, and so forth. And then one of the guys that we barred won the goddamned car! That really ticked me off," said Parks.

Gardena Poker Clubs

When the City of Commerce, located twelve miles northeast of Gardena, granted a card club license and opened the $20 million California Commerce Club on August 1, 1983, the club touted itself as the world's largest card club, with one hundred tables. The club's president, Frank Sansone, boasted of the sixty-five-thousand-square-foot club, "It's head and shoulders above any other card club and I don't just mean the ones in Gardena."

A week later, the Rainbow Club folded, closing its doors at 4:00 a.m. on Saturday, August 6. Parks received the club's death notice earlier that night via a telephone call at home, notifying him that there was no longer enough money to cover the chips held by the crowd of one hundred currently playing at the tables. "We were running on a very thin cash margin," said Parks, who went on to explain that the club's funds had been almost completely drained when they'd issued the employee paychecks the day before.

Parks took on the somber duty of making the 4:00 a.m. announcement at the club to the employees and players. Two Gardena police squad cars arrived at the Rainbow in advance of the announcement to ward off any trouble that may have arisen, but the players all walked out quietly. Finally, the three hundred employees were locked out, lining up outside the club's entrance for their final paychecks. A sign posted on the club's front doors read "Temporary Closed," but the club would never open again. Parks informed the press:

> We were on the borderline anyway, and when Commerce opened it was just too much. There are only so many poker players to go around in Los Angeles County, and with seven clubs open they were spread too thin. We just ran out of money....It's sad. We had some very loyal customers, some who had been with us for 30 years.

George Anthony made the smart business decision of honoring the outstanding poker chips from the Rainbow Club and securing some of its lost customer base. The move cost the Eldorado somewhere between $20,000 and $25,000. Parks praised Anthony's efforts:

> We had a lot of customers with outstanding chips out there and none of the clubs would honor their chips and take them—except George Anthony. He took them because George knew that those people who cashed their chips at his club would probably stay and play—and they did. And they became customers. George was smart that way.

A High-stakes History

Rainbow Club closing, 1983. *City of Gardena Archives.*

Councilman Mas Fukai, a longtime opponent of the card clubs and unsympathetic about the end of what had become one of the city's oldest institutions, cited mismanagement as the culprit. "There's no rhyme or reason for the Rainbow Club to close and not the others if it was just the competition. It has to be bad management." George Hardie, the flamboyant general manager of the forthcoming Bell Gardens Bicycle Club, echoed the councilman's sentiments, stating, "I think Gardena has been going downhill for a while now. I think the owners have become complacent. They've done nothing to attract new customers. They don't offer any amenities, they don't seem to have an interest in security, they don't explain the game to new players."

Nevertheless, the Rainbow had hung on as long as it could, with declining revenues so bad that the club's forty investors had not received any dividends since 1980. Up until its closing, the Rainbow Club had been saddled with the financial burden of paying off the Monterey's debts. Gary Primm had already left Gardena, relocating to State Line to work on Whisky Pete's. Insiders close to the situation knew that the Primms had been looking to exit Gardena for several years because the clubs were starting to have difficulty with new competition from elsewhere in the county.

The only Gardena club paying its stockholders dividends during the summer of 1983 was the Horseshoe Club, with revenues estimated to be in excess of $1 million per month. Gardena's city manager, Martin Reagan,

The Horseshoe Club. *City of Gardena Archives.*

speculated that the Rainbow Club's closing could only benefit the other Gardena clubs if the customers stayed in Gardena and didn't migrate to the county's newer poker palaces. He worried about the effect it would have on the city budget, which was already taking a hit from the closure of the Monterey. Two years earlier, the clubs had paid the city a combined $4 million, but now that annual figure had fallen to $3 million.

Former mayor and attorney Edmond Russ, who was now representing the clubs through his law practice, advised the city council that they were on the verge of a bigger disaster, declaring a state of emergency in the wake of the Rainbow folding: "It really is an emergency when you're talking about the biggest source of revenue in this community possibly being dried up." With pressure on the city council from George Anthony and the Gardena Card Clubs Association, the city loosened its restrictive ordinances, expediting permission for the clubs to serve liquor in their restaurants and add an additional five tables. The city also abandoned closing hours and the closing day rules, allowing advertising and giveaway promotions to lure back customers.

Encouraged by the city's newfound willingness to stay competitive, Anthony said, "We got most of the laws we had against us repealed. Now we can really compete." However, anticipating more troubles ahead with more cities getting in on the poker club act and siphoning away Gardena's fragile customer base, Anthony maintained that only the strong would survive.

A High-stakes History

Above: The New Gardena Club and Four Queens Bar, 1980s. *City of Gardena Archives.*

Left: The New Gardena Club brochure. *City of Gardena Archives.*

The New Gardena Club
15446 S. Western Ave.
213-323-7301

You'll delight in the exciting atmosphere of the New Gardena Club. Smiling, enthusiastic employees make your games particularly enjoyable. Play here is always animated, never dull.

When you relax from the excitement, you'll have a real treat in store in the club's outstanding restaurant. The chef takes special pride in presenting a wide variety of delicious delicacies at exceptionally reasonable prices.

Don't miss the New Gardena Club, a thoroughly pleasant place to play.

In its final years, the New Gardena Club had become the bottom of the barrel for poker players. It's where the cheaters would go. Rejects who got kicked out of all the other clubs would end up playing there. Those familiar with the club remember that there was also a lot of awful polyester on display at the New Gardena Club. But in 1984, when the City of Bell Gardens, located eleven miles northeast of Gardena, opened the flashy new 104-table Bicycle Club and the 70-table Huntington Park Casino opened eight miles northeast of Gardena, customers left in droves. The New Gardena Club closed its doors for the last time in October.

Just fifteen years earlier, the prospects of suburbs throughout Los Angeles County's industrial rust belt were tied to the fates of huge factories, such as South Gate's General Motors assembly plant and Firestone tire factory. But between 1979 and 1982, they were ravaged by deindustrialization as a tidal wave of Japanese imports washed away most of California's heavy manufacturing. Inspired by the $11 million in annual revenue that the Bicycle Club was now pumping into Bell Gardens' city coffers, making up 55 percent of the city's municipal budget, the threat of more future card clubs taking bites out of Los Angeles County's poker economy loomed large.

It was in this period of the mid-1980s that the years of great revenue from Gardena's card clubs to the veterans' groups finally trickled down to nothing. Monthly payments by the Horseshoe Club to the Gardena American Legion post had at one time exceeded $10,000. After the clubs began to fold, the licenses diminished in value, and the American Legion eventually cashed out and sold its license to the Horseshoe Club.

However, a changing tide was about to wash through the L.A. card club industry with the addition of pai gow (pronounced PIE-gow), a complex Asian game involving domino-like tiles that had been played illegally for years in back rooms, attics and private clubs, from Los Angeles' Chinatown to suburban Orange County.

Prior to Asian gaming, the only thing on offer at Gardena's card clubs was poker. But that all changed when the Miller family was approached by Chinese promoter Tony Wong, who proposed bringing the game of pai gow tiles to the Normandie. Up until this point, pai gow was an underground sensation that had originated in thirteenth-century China. Wong was convinced that by putting it in the card clubs, the game could become a huge hit.

In an effort to modernize the club, in November 1980, Miller moved the Normandie from 148th and Western Avenue to a new twenty-five-thousand-square-foot $4 million building designed by Gardena architect Mark I.

A High-stakes History

A promotional image featuring the Normandie Casino's main entrance at the club's final location on Rosecrans Boulevard. *Miller family archive.*

The Normandie Club
1045 W. Rosecrans Ave.
213-515-1466

The Normandie Club, a brand new $4 million facility, is Gardena's newest and largest casino.
Just west of the intersection of Rosecrans and Vermont, the club features draw poker, both high and low.
The friendly atmosphere of this family owned and operated club spills over into the outstanding restaurant, where Chef Lorenzo creates his culinary masterpieces.
A special feature at the Normandie are the exciting Dealer Jack-pot games. The club has given away several hundred thousand dollars to lucky winners.

A Normandie Club brochure. *City of Gardena Archives.*

125

Murakami. The club's new location at Rosecrans and Vermont was across the street from the Horseshoe Club. Miller hoped pai gow would give him an extra edge in the intense competition of luring card players.

When the Gardena City Council approved an American version of pai gow in the fall of 1984—with rules prohibiting side betting, a common practice at pai gow games that violated California law—Miller agreed to take on the risk of adding the new game. He decided to put it in an area of the Normandie that had formerly been the club's library room. The room was only about the size of a small swimming pool, but on opening night, there were four hundred people packed in there, literally hanging on each other for space. Pai gow tiles was an instant success and prompted the Normandie to begin catering heavily to a new Asian clientele.

Up until this time, most of the Normandie's players had come from West Los Angeles. But with the new introduction of pai gow, customers began to come from untapped locales, such as Monterey Park, Koreatown and Chinatown. Patrons of the time recall how many of the Asian players from that period dressed in a standard issue uniform of black suits with white shirts and wore their hair like Rod Stewart.

The Asian influence proved so popular that the Normandie revamped its restaurant to accommodate a variety of tastes, including Mandarin, Vietnamese, Thai and Korean alongside the longtime standard Continental menu. Players could now order dishes like Wor Wonton soup with duck from the Normandie's twenty-four-hour Paddle Wheel Restaurant. Soon after that came pai gow poker (an Americanized version using cards instead of Chinese dominos), then Pan 9 (Super 9). The club also introduced the Red Dragon Room for VIP Asian games. Around this time, Lee Miller invented a game called blackjack jokers, which became an entryway into Vegas-style blackjack. Years later, the Normandie would offer a game like Vegas-style blackjack, but back then they had to get around it by having two jokers being the highest card, instead of it being an ace picture. Eventually, nearly half the club would be dedicated to Asian-style games.

By early 1985, six of the county's seven card clubs were offering pai gow. Only the California Commerce Club abstained, over initial concerns about the game's pending legality. In January 1985, the game was finally ruled legal in Los Angeles Superior Court after the Huntington Park Casino filed a lawsuit in response to having its pai gow games shut down by law enforcement. Offering pai gow was seen by club operators as an opportunity to tap into a vast new pool of players and potential earnings in an oversaturated poker market.

A High-stakes History

In February 1986, the Gardena City Council voted on an ordinance that would allow the card clubs to finally serve alcoholic beverages to players seated at the card tables, a practice already allowed by the other clubs in Los Angeles County. It was Edmond Russ who campaigned hardest for support from the councilmembers, contending that the clubs' revenue could increase by 25 percent if liquor was served at the card tables. The council approved the ordinance by a 3–2 vote but noted that the gross receipts from the clubs had actually decreased every month since they had begun serving alcohol in their restaurants in 1983—a warning sign that outside competition was seriously weakening the local industry, even after the city's repeal of old restrictions.

Gardena, with its nearly fifty-year card club monopoly, had derived 25 percent of its annual revenue from poker clubs. But in recent years, with stiff outside competition luring away customers with bigger, flashier clubs in neighboring communities, the portion of the city's $25 million budget generated by card clubs had fallen to a mere 8 percent. This prompted Gardena to look to its transnational connections for economic growth, and the city evolved into a major industrial gateway to the Pacific Rim. Plans were drafted for the construction of the $22 million luxury Eldorado Hotel, designed to be a joint venture financed by Japanese and American investors. The hotel would primarily cater to Japanese businessmen. With the influx of Japanese banks and companies—such as Honda, Toyota and Seiko—Councilman Paul Tsukahara affirmed, "The Japanese community, not the card clubs, has proved to be the real source of our economic strength." Referencing the area's post-1965 white flight, he continued, "Nearly everybody else had written off the city, including many Caucasians who took off for greener pastures in Orange County and so forth."

The Eldorado Club, site of the new proposed hotel, was now less than two miles away from an area near the intersection of the Harbor and San Diego Freeways, where major corporations had moved in. Touted as the next Century City, the nearly three-square-mile sprawl of glass and steel office buildings included Nissan, Thompson Ramo Wooldridge, Toyota, Pacific Bell, Mitsubishi Electronics, Texas Instruments, Bridgestone Tire and American Honda.

According to his own estimates, George Anthony spent six years and $700,000 planning his new hotel. However, just as in the card club business, competition loomed, with five other similar hotel projects proposed for nearby cities. Always a gambling man, Anthony weighed up the risks, pointing out that the twenty-two banks along Gardena's Redondo Beach

Boulevard were evidence of the big pot of money up for grabs. "Those [banks] show the foundation of the [business] empire here. We're in a hub, like the spokes of a wheel here, with the Harbor Freeway, the Artesia Freeway, the San Diego Freeway," Anthony boasted, while also pointing out that Gardena, geographically, was less than a twenty-minute drive away from downtown Los Angeles, the Port of Los Angeles and LAX International Airport. He also acknowledged that the whole project was a gamble: "I could lose. I don't think so…but it could happen."

With the city now down to just three card clubs, the monthly combined city revenue averaged $170,000, and Gardena was heavily invested in Anthony's vision. City officials projected that the sixteen-story, 253-room high-rise hotel could generate more than $500,000 in yearly tax revenues. In an effort to see the project through, the city pinned its hopes on a $3.5 million federal Urban Development Action Grant that would serve as a catalyst for private financing. The grant money would be lent to Anthony and then later repaid to the city, providing an incentive for construction without risking city funds.

By the spring of 1986, Anthony and his new partner, Beverly Hills investor-developer William Taylor Peeler, announced groundbreaking plans for their Eldorado Center, a beefed-up version of the original Eldorado Hotel plan that now featured the addition of luxury office space and a financial center as part of what would now be a behemoth $55 million executive suite. Plans included an eleven-story, 203,000-square-foot office complex in addition to a 317-room, seventeen-story luxury hotel, with the two buildings sharing a "space frame" lobby. Designs for the building had come from Los Angeles architecture and engineering firm Hellmuth, Obata and Kassabaum, with J.A. Jones Construction Company of Orange and Hazama-Gumi Ltd. of Tokyo and Los Angeles serving as general contractors. The hotel would be managed by Tokyo's Sunroute Hotel System, the Pacific Rim's largest hotel chain and operators of the Disneyland Hotel in Tokyo.

The bulk of the financing would come from a $33 million loan by the International Brotherhood of Electrical Workers union, with an additional $11 million City of Gardena bond issued for the facility's six-level parking garage and an $11 million combined investment from Anthony and Peeler, with groundbreaking set for December 12. The developers estimated an eighteen-month construction schedule, with the grand openings for the office complex on January 11, 1988, and the hotel on July 4, 1988. City councilman Paul Tsukahara praised the project and its new projections of $750,000 in additional annual tax revenues, stating, "Up until now, Gardena

has been a town. It can't be a city without a first-class edifice such as this hotel, which will really be a centerpiece for our city."

Worried residents of adjacent Berendo Avenue came out in protest of the planned groundbreaking, fearing that their suburban homes would be overshadowed by the towering complex. Concerns about local residential streets being overrun with overflow parking and hotel guests having bird's-eye views into the surrounding homes challenged the developers at an informal city hall meeting in late December. Peeler did little to quell the neighboring residents' concerns, telling the group about the thousands of dollars in annual tax revenues that would be generated by the center and how the hotel would be full of wealthy executives from Japan.

Nevertheless, in May 1987, with a crowded audience including members of the city council, Anthony and Peeler hosted honorary guest California Republican U.S. senator Pete Wilson, who shoveled the first piles of sand, signaling breaking ground and the beginning of construction. As shovels dug into the soil, Mayor Don Dear remarked, "We couldn't imagine anything like this being built here forty years ago, when we were just a small farm town." But the planned development stumbled in the months ahead, with red tape delays preventing construction. As shaky bond and financial documents were redrafted in vain, city manager Ken Landau reassured the city that the Eldorado Center was still going to happen—but the project was doomed.

It was in this period that Gardena's card clubs, which had resisted for so many years the "casino" label, eventually decided to change their image and embrace the Vegas comparison. With the introduction of house dealers at the tables, Gardena's clubs had started to look more like Vegas. The Normandie Club rebranded itself as the Normandie Casino and crafted a "Vegas-in-L.A." promotional campaign, distancing itself from the stigma of the old-fashioned poker halls. The *Los Angeles Times* also agreed to begin advertising gambling and ran a series of ads for the Normandie Casino.

In the fall of 1987, Blaine Nicholson, now representing the Normandie Casino for marketing and public relations, began experimenting with live entertainment, drawing on his prior experience of putting on successful revue shows for Primm's Primadonna casino in Reno. "Ninety percent of the people in Los Angeles County don't even know these clubs exist….The important thing is to introduce to the people that there's entertainment here," Nicholson told the press.

Entertainment came in the form of Elvis Presley and Frank Sinatra impersonators and cabaret shows like the musical comedy revue *Big Spender* performing for audiences on stage in the Normandie's dining room. The

GARDENA POKER CLUBS

"Vegas-in-L.A." magazine ad. *Blaine Nicholson.*

A High-stakes History

Vegas-in-L.A. campaign included newspaper and billboard advertising featuring images of glamorous showgirls and the excitement of players enjoying elegant dining and winning jackpots. It also reinforced the club's convenient location for Angelenos, using the taglines "Why go all the way to Vegas to try your luck!" and "Come play the Vegas-Way right here in L.A." The Horseshoe Club also attempted the lure of live entertainment, featuring lounge acts in the club's bar area. Card players sitting in the Normandie's smoky game room seemed skeptical over the club's new draw, with one crusty old gambler joking how he'd rather be watching the dinner show: "Why? Because I'm on my can, broke, that's why."

Even amid the economic lull of the early '90s, in 1992, the Normandie Casino put the finishing touches on a $3 million renovation that included the new 240-seat Showboat Showroom. The turn-of-the-century-style theater featured large video screens and a waterfall-style rain curtain. The theater made its television debut when cable television network BET taped early seasons of the classic stand-up comedy series *Comic View*, hosted by comedian D.L. Hughley. Nicholson compared the club's live entertainment expansion to early Vegas, saying, "Vegas used entertainment to draw California residents across the desert to their casinos. We're doing the same thing. We needed a way to bring people here." Over the years, the Normandie would

Normandie Casino's "Vegas-in-L.A." campaign billboard advertising the new attraction of live entertainment. *Blaine Nicholson.*

play host to big names such as Nancy Wilson, Vicki Carr, Crystal Gayle, Helen Reddy, Dave Mason and Blood, Sweat & Tears. But there were always skeptics. Quick-witted George Anthony shook his head at the Normandie's entertainment venture, scoffing, "I don't see entertainment as the future. These aren't hotel casinos. To have somebody dancing while you're playing cards takes away from winning money. When you're gambling, you ought to be gambling, and gambling to win."

The Normandie's eighteen-thousand-square-foot expansion project included the addition of a new bar, a gift shop and, for high rollers, the Dragon Room and King Dragon Room. Now featuring eighty tables, the club firmly pinned its hopes on the prospect of live entertainment and new Asian games making it competitive against Los Angeles County's five other card clubs. However, after the L.A. riots of 1992, the showroom experienced a dip in attendance. "When the L.A. riots hit, that just practically closed down that showroom. People were afraid to go south to Gardena. Eventually though, they began to come back and it didn't hurt the gambling or the poker at all. But people who would've come out to the shows, I think, were scared away," said Nicholson.

Other clubs had to find equally creative ways to attract more customers. In 1987, the Huntington Park Casino and the California Bell Club won a lengthy lawsuit challenging the old 1872 gambling statute, and this time, the court ruled that all non-banked and non-percentage poker games were legal. This included the three most popular card games in Las Vegas: Texas Hold 'Em, seven-card stud and Omaha. Sam Torosian, manager of the California Bell Club, declared, "This is the best thing to happen to poker in California since the Gold Rush." By the summer of 1988, with a new wave of prosperity about to hit California's card clubs, Gardena's three clubs braced themselves, as players arrived from as far away as Nevada, Texas and the Pacific Northwest. Compared to the new exciting offerings of stud and Hold 'Em, traditional draw poker felt like chess. For the first time, players in California were being offered a Vegas-style experience without the four-hour drive and hotel room. Las Vegas casino officials complained that even they were losing some of their regular poker players to California's new poker gold rush. "Lots of those who make a living at poker are in Southern California hoping to catch a few novices asleep at the deal and make a quick dollar or two," said Eric Drache, organizer of the World Series of Poker and resident poker manager at Las Vegas's Golden Nugget Hotel.

A High-stakes History

Promotional photo of high rollers in the Normandie Casino's VIP King Dragon Room. *Blaine Nicholson.*

But not all the clubs in Los Angeles could benefit from the new boom. After decades of lucky prosperity, the money machine that had been the Horseshoe Club finally came to a grinding halt. Years of paying dividends to the approximately forty partners without any reinvestment led to the poker palace—which in the 1960s brought in as much as $750,000 per month—virtually falling apart. Problems surrounding an attempt to transfer the Horseshoe's license had thwarted efforts to buy the club by former Commerce Casino president Herbert Stern. The Horseshoe finally closed on May 23, 1989, under protests from the employees. Sherry Littleford, the Horseshoe Club's employee coordinator, stood on a weeklong picket line with fifty other employees, lamenting, "If they don't give us a chance to reopen, a piece of Gardena history is going down the drain." Twelve months later, the city established a plan to demolish the forty-one-year-old club, making way for a 38,500-square-foot shopping center.

With Gardena now home to only two clubs, the city council finally agreed to repeal the signage ordinance when the Normandie Casino requested

The Horseshoe Club brochure. *City of Gardena Archives.*

permission to erect a towering sixty-five-foot sign at the front of the property along Rosecrans Avenue that would be visible from the nearby Harbor Freeway. Attorney Edmond Russ pointed out to the council that the Eldorado and Normandie were now collectively bringing in the same amount of annual revenue that all six Gardena clubs did when they were operational (approximately $4.97 million). Considering the increased competition from the county's other card clubs, the council finally agreed to a new sixty-foot sign for the Normandie.

Ever since the early 1940s, Gardena's card clubs endured numerous robbery attempts of both employees and patrons. However, the most brazen of all occurred at the Normandie Casino during the spring of 1995. In a move straight out of *Ocean's 11*, two creative thieves pulled off a heist by impersonating armored car guards. The tip-off should have been that the thieves arrived in a van with a red Loomis logo branded on the side. Loomis Armored Inc. only used armored trucks for its pickups and had no vans in the company fleet. Not recognizing the thieves were imposters, security

guards escorted one of the men into the club cashier's office and loaded his black canvas bag with $210,145 in cash and checks. The thief signed for the money and drove away. Employees were stunned twenty minutes later when the actual guards from Loomis arrived in the real armored truck. A month later, Gardena police cracked the case, arresting a local man in connection with the robbery. Luckily, the casino was insured against theft.

When the Hollywood Park Casino opened in neighboring Inglewood in July 1994, the Normandie Casino suffered a 20 percent drop in business for the year. By April 1996, the City of Gardena was becoming acutely aware that the Eldorado Club was unraveling. George Anthony had resigned as general partner in March, and the club had stopped making payments and reporting revenue to the city. Speculating that the club was folding, the council began evaluating what could be done with the vacated license. California's recent moratorium on new gaming licenses meant the Eldorado's license was now worth as much as $5 million.

The Eldorado filed for bankruptcy protection on May 24, claiming total liabilities of $11 million against assets valued at $15.3 million. Under the protections of Chapter 11, the Eldorado continued to operate while reorganizing its finances. Industry experts asserted that, by 1990s' standards, Anthony's twenty-eight-year-old club was really "showing its age." Sol Leonard, a Century City–based gaming and hotel consultant, summed up the situation: "They can't match the ambience of the clubs in Commerce or Hollywood Park over in Inglewood. There was talk of a sale but it never came to fruition." As a last-ditch effort to save the Eldorado, in late August, the city unanimously agreed to reduce the annual amount of tax due from its two card clubs from 15.5 percent to 12 percent. "We hope that by reducing the gross rentals [taxes] it will give them enough money to promote and expand and do the things necessary to bring extra players in," said city manager Ken Landau.

Stephen Miller, owner of the Normandie Casino, planned to take advantage of the tax break by installing a much-needed smoke filtration system and upgrading the club's air conditioning. The Normandie's low ceilings harbored a perennial cloud of cigarette smoke that made anyone who came through the doors feel as though they'd inhaled an entire pack of Marlboros. Miller also planned to copyright some original card games and add them to the club's roster.

Yet on the morning of September 11, 1996, the Eldorado Club, down to operating only twenty-two tables in its final weeks, locked its doors behind a marquee sign stating the venue was closed for remodeling. Phone calls to

the club and its attorney went unanswered, leaving the city in the dark about the club's reorganization plan. But it was understood that this was the end for the Eldorado. "It's sad. It's like an old friend. They were always generous with helping the city," remarked Councilman James Cragin.

Behind the scenes, the Eldorado had accrued an additional $150,000 in debt since filing for Chapter 11. Employee paychecks for the club's final pay period, totaling $72,000, bounced, as the club's bank accounts ran dry, leaving behind $55,000 in unpaid wages. Those closely monitoring the bankruptcy case speculated that it was likely the judge would order the trustee to liquidate, converting the Chapter 11 filing to a Chapter 7 case. By the time the bankruptcy court's inspector came to tour the club, he did so by flashlight, as the property's utilities had been shut off. Mayor Don Dear gave the most realistic prognosis, stating, "We don't expect it to reopen. There was some talk of them bringing in new investors, but with the state of the industry, it may not be the best place to invest. I hate to say it, but it's true."

Almost as if to fill the void left behind by the Eldorado, Compton's $30 million 112-table Crystal Park Hotel and Casino opened during the fall of 1996. Compton's most famous mayor, Omar Bradley, said of the project, "There isn't a government agency right now that's not strapped for cash. If we can make money without spending money, that is the kind of business we want to bring to the city of Compton." But this brand of optimism was really just in vain, as casino revenues slumped across the southland. With new casinos also planned for Palm Springs, Coachella and Hawaiian Gardens, the pool of Southern California card players was about to become even more diluted.

It was around this time that the area formerly known as "State Line" and often called "Primm Valley" officially changed its name to Primm, Nevada, named for its pioneer developer, Ernest Jay Primm. The city of Primm straddles Interstate 15 and lies approximately forty miles to the south of Las Vegas. Gary Primm, sentimental about his father's original vision, said, "When I reflect back on the dreams my father had for this area, I feel a lot of emotion. It's a tremendous highlight for our family to have something like this named after him."

The naming ceremony took place a month in advance of the opening for the Las Vegas strip's newest addition, New York–New York, a venture in which Gary Primm was co-partner. After the death of Ernie Primm, Gary went to work realizing his father's dream of creating a modern gambling oasis on the state line. Gary took things to the next level, building the Primadonna in 1990, now called Primm Valley, and Buffalo Bill's in

A High-stakes History

Gary Primm with Bonnie and Clyde's death car on display in Primm, Nevada. *Blaine Nicholson.*

1994. The monorail-connected gambling mecca featured attractions such as "Desperado," the world's tallest and fastest conventional roller coaster at the time, and Bonnie and Clyde's notorious "death car," with 167 bullet holes. In a macabre incident involving the construction of the monorail

Gardena Poker Clubs

California-bound interstate traffic leaving Primm, Nevada. *Max Votolato.*

connecting Whisky Pete's to Buffalo Bill's Hotel and Casino, construction workers accidentally exhumed the grave of Pete MacIntyre. The body was moved and is now said to be buried somewhere in the nearby caves where MacIntyre made his moonshine in the old days.

The Primm family businesses, consisting of three hotel-casinos with collectively nearly three thousand rooms, a one-hundred-store outlet mall, two gas stations (together pumping over fifteen million gallons a year) and two championship golf courses, all under the banner "Primadonna Resorts," and their 50 percent interest in the New York–New York Las Vegas casino were merged with MGM Grand Inc. in 1999. The properties were resold in 2007 to the Affinity Gaming Company for $400 million, without the Primm Valley Golf Club. It's estimated that one out of every four drivers headed in either direction through Primm will stop, giving the area approximately ten million visitors a year.

7

HUSTLER

In the aftermath of the Eldorado Club's bankruptcy, three bidders emerged from the sidelines ready to take the reins of the defunct hacienda-style casino. The first bidder was Bill Fleischman, owner of the nearby Roadium Open Air Market in north Torrance (a former drive-in movie theater turned swap meet). Fleischman's Century City company W/F Investment Corporation bid $1.6 million for the licenses, requesting a $20,000-per-month lease and the option to buy the property outright for $5 million. "We think it would be a good investment. It operated profitably there for years, and we believe we can make money there," Fleischman said of the proposal. His plan for the property also included the realization of the dream that always eluded George Anthony: the addition of a new hotel and parking structure.

The next bid was unofficial and came from the Normandie Casino, whose attorneys proposed an unknown sum to the bankruptcy court, overbidding on Fleischman's original proposal.

The final bidder was Larry Flynt, owner of Larry Flynt Publications, a massive Beverly Hills publishing empire with annual grosses estimated at $135 million. Flynt, a former adult club owner—famous for his publication *Hustler* magazine and well-publicized First Amendment court battles—at first seemed an unlikely candidate. Gardena City manager Ken Landau surmised, "We have serious doubts about whether Mr. Flynt could receive a license from the state." However, nobody had any doubts about Flynt's financial clout, as the Flynt Publications initial bid proposed $1.8 million

for the licenses and a $35,000-per-month lease with an option to buy the property for $5.5 million.

City officials, cold to the possibility of Flynt owning and operating a casino in Gardena, began evoking sections of the municipal code that hadn't come into play since the days of the Kefauver committee, with talk of denying the application on moral grounds, "if the applicant is not a person of good character, integrity and honesty." In reality, the code section that dealt with gaming license applications did not include those same grounds for dismissal. Only the final section would permit the council to dismiss a license application on moral grounds "if the approval of any applicant would be inimical to the interests of legitimate gambling."

The biggest elephant in the room was the fact that the city had very little choice but to go forward with Flynt as the highest bidder. Gardena was standing on shaky financial ground, already facing a general fund deficit of approximately $4.1 million, with a large portion of that debt incurred by the $1 million in back taxes owed by the Eldorado and funding for the parking structure bonds that the city had issued to the club.

Soon after, Flynt upped the ante by delivering a $100,000 check to the federal bankruptcy court trustee as a show of good faith and to ward off any concerns that, given a choice, local and state politicians wouldn't opt to approve one of the other bids first. Flynt's offer detailed how he would purchase the Eldorado's license, pay off the creditors and back taxes and then

Larry Flynt in his Beverly Hills LFP offices. *Max Votolato*.

forge ahead with the process of getting his application approved by the city council and state regulators. Flynt also requested the right to sell the license in the event that his application was unsuccessful. Alan Isaacman, Flynt's longtime friend and attorney, said of the offer, "This makes a statement, that we are serious. Flynt is a good citizen wherever he resides. He's been in Beverly Hills for years. He'll make a first-rate card club in Gardena, and we believe the city council and city leadership will act in the best interests of Gardena's citizens."

Flynt's interest in the casino venture was initially prompted by a letter he received from a concerned Eldorado Club employee named Maggie Mundet informing him that the club was now for sale. When asked why she had chosen to approach Flynt, Mundet explained: "I just felt he was the person who could run this place. Mr. Flynt is a fabulous person. He is intelligent and witty. He is going to make a terrific owner." Mundet also sent a letter about the club to entertainer and game show guru Merv Griffin. Griffin never responded, but two weeks later, Flynt got in touch, telling the press, "Quite frankly, it looked like a good business opportunity to me. And I've always wanted to own one. I've been a gambler all my life, and I know people in the industry that can operate this properly."

Opponents of Flynt's bid contended that, due to his notoriety as a pornographer, no elected official would ever take on the liability of voting to sell him the club, challenging that he would face massive legal obstacles in comparison to the other bidders. But Flynt maintained that his record was clean; despite numerous attempts to convict him on obscenity charges and time in jail, any felonies he'd ever been convicted of had been overturned by the courts. However, with the licensing of legal gambling being among the strictest in the world and having the least constitutional protections, experts argued that Flynt could be disqualified on the grounds of being guilty by association with anyone considered unsavory enough to bring disrepute to the industry.

With mounting pressure from the city's moral advocates and residents expressing fears that the new card club would be populated by scantily clad or nude hostesses, Flynt discouraged rumors that his casino would be a venue for adult entertainment, stating, "I want to assure the community that models will not be on the premises. I'm planning to put a lot of money into this. This is going to be a class operation. The city will be proud." But an immediate propaganda battle began in Gardena, orchestrated by Republican South Bay political consultant Tom Shortridge, with fliers circulating throughout the city calling on supporters to "Stop Larry Flynt

and His Hustler Casino." The fliers went on to declare, "Apparently, Mr. Flynt wants to expand his empire from pornography to gambling. Pornography and gambling under one roof!"

Flynt's camp fired back at Shortridge's political attacks, issuing its own rebuttal flier titled "The Facts vs. The Fiction: Don't Be Fooled by the Lies!" The flier exposed Tom Shortridge and his smear campaign as a smokescreen for Fleischman's W/F Investment Corp and its competing bid. It also detailed how Flynt's lucrative bid and stable financing were more beneficial to the city, boasting, "Rather than seek free rent, Mr. Flynt plans to purchase the real property, thus substantially increasing his investment in the city of Gardena."

On December 15, 1997, federal bankruptcy court judge Samuel Bufford finally gave Flynt permission to purchase the Eldorado Club—along with its liquor and gaming licenses—for $7.1 million. As part of the deal, Flynt would also be required to pay the City of Gardena $900,000 for bonds that had been floated to pay for the unconstructed parking garage next to the casino. The court also gave Flynt a February 17, 1999 deadline for obtaining his gaming license with the contingency that, if he missed the deadline, another party could apply for the license and operate the club on his behalf.

Nearly a year later, with affirmative votes from the city council and planning commission, plans were underway to demolish the old Eldorado and replace it with a new two-story casino. The new forty-five-thousand-square-foot structure would be a twenty-four-hour operation—55 percent bigger than the Eldorado—featuring a sports bar, an Asian American restaurant and sixty tables for high-stakes poker and California-style card games.

Initially, Flynt was approved for a gaming license by the City of Gardena, but the State of California did not immediately approve him. In order to open the casino on schedule, Alan Isaacman took on the surrogate role of business owner, while Flynt played the role of landlord. According to Flynt, "It was very challenging. We had to jump through a lot of hoops. But we were determined. It took me about three years to get the license transferred into my name. It wasn't an easy accomplishment."

But there would be one more battle waged before the first hand of cards could be dealt. In September 1999, Reverend George Villa, president of the ninety-member Gardena Ministerial Association, started a crusade to prevent Flynt from using his controversial "Hustler" brand name in connection with the new club. Reverend Villa charged that "Hustler" was "a name affiliated

with pornography and…society's worst elements. A name like 'Hustler' is going to draw a lot of questionable people with questionable conduct."

Flynt later recalled the controversy with a sly grin: "At first it started with the name 'Hustler.' City Council would not approve the use of that name. They said it denoted a male prostitute. Now if you look at Webster dictionary, it just says that a 'Hustler' is an aggressive person." Some city officials held out hope that Flynt would maintain the original club's name and call it the "New Eldorado Casino." However, with fierce competition between card clubs throughout the county, it was imperative for the club to have a marketable name that would stand out and be commercially viable. "I have found that my name has some value when it comes to marketability. And we would use 'Hustler' in some form in the name. That's why I can make this work," Flynt contested. Longtime Gardena resident Bea Bernstein recalled the Hustler brand controversy: "I didn't object to it because I liked him.…I believe what he believes, in free speech no matter what it is." Ultimately, the city attorney determined that the council couldn't force Flynt to change the name.

After months of delays due to complex construction, the $30 million Hustler Casino finally opened in June 2000. The crown-shaped neon building, designed by Venice-based architects Ron Godfredsen and Danna Sigal, was a symbol of oughties new-age Los Angeles architecture, such as Frank Gehry's Walt Disney Concert Hall. Terracotta tiled walls dotted with flashing circular portholes (jewels in the crown) captured the attention of every passerby. The neoclassical interior, with its brushed aluminum ceiling, was done up in Flynt's favorite colors of gold, purple and burgundy and featured giant icy chandeliers, French provincial furniture and oversized replicas of Gustav Klimt paintings on the upholstered red mohair walls. Giant gilt-framed flat-screen televisions adorned the walls, broadcasting

Hustler Casino sign erected. *Al Underwood*.

non-stop sporting events. A giant smoking atrium with a dome open to the stars, a restaurant adorned with mosaic walls and Venetian-type lamps, the Hustler boutique and an upstairs sports bar featuring a backlit marble bar and luxurious modern green booths rounded out the venue's attractions, in addition to the many poker and blackjack tables on offer.

The Hustler Casino proved to be an instant success, jammed day and night with customers playing a variety of card games, including forty- to eighty-dollar poker games, Texas Hold 'Em, low ball, seven-card stud, pai gow and Super Pan 9. "It wasn't as easy as I thought," recalled Flynt. "We got off to a rocky start. All the employees we hired turned out to be rejects from the other clubs, and it was a nightmare. It took three or four months to get all the bugs out." Years later, Flynt described the level of success garnered by his casino, stating, "I've got thirty-two entities, and it's not all publishing. Some of it is apparel, video business, chain of retail stores, but the Hustler Casino actually constitutes almost fifty percent of our profit. It's huge."

Not only was it a financial success, but Flynt had also won respect and admiration from the skeptical community of sixty thousand. Friends both inside and outside of city hall heaped praise on Flynt for restoring much of the luster of Gardena's bygone era. Just like proverbial street fighter Ernie Primm, Flynt was cut from the same cloth and had carried the city's legacy into the twenty-first century. In recent years, nearly one-fifth of Gardena's operating budget had come from the revenue generated by the Normandie and Hustler, equaling roughly $10 million per year in taxes paid by the clubs. This made the card clubs' gross revenue fees the city's highest source of income after revenues from sales and use tax.

As the 1990s slipped away, so, too, did the remaining giants who had ruled the kingdom of the Gardena card clubs. The first to go was the ninety-year-old Normandie Club patriarch Russ Miller, who died of pneumonia at St. John's Health Center in Santa Monica on December 26, 1997. Miller left the Normandie, now the fifth-largest club in California with eighty tables and eight hundred employees, in the hands of his four sons. Blaine Nicholson wrote in Miller's eulogy:

> *He was a good skipper, guiding his business through the rough seas of political uncertainty, difficult partners, fierce competition and bad economic times. The business survived and prospered. The family survived and prospered. He now turns the ship over to his sons; the ship is in good hands.*

A High-stakes History

Russ Miller and his wife, Mary Ellen Miller, whom he had first met when she was working at the Embassy Club as a chip girl back in the early '40s, were always known as paragons of generosity in the community. In recognition of a lifetime of contributions to the city, Russ Miller was added to the Gardena Wall of Fame in 1998. Mary passed away in 2001. After her husband's death, she continued her charitable efforts and oversaw operations at the Normandie. Mary was a strong believer in the value of education and created the B or Better Foundation to help reward good students. She wanted everyone to have the opportunity to go to school, even if they were working. The foundation was designed to encourage Normandie employees to take classes, if they could manage them on top of their workloads. When employees took a course or a class and achieved a grade of B or better, they would receive $100. For every $100 that an employee was awarded, matching funds would be put into the B or Better Scholarship Fund. Each spring, local high school students would participate in an essay-writing contest, and the winners would be awarded money from the fund as scholarships.

George Anthony died in his sleep at the Carson Retirement Center on October 17, 1998, one day after his eighty-fifth birthday. The innovative natural leader, who had united the card club owners and led the fight to permit alcohol and twenty-four-hour gambling, had succumbed to his final battle with Alzheimer's. Anthony, always a risk taker, summed up the secret of his success: "There is an old saying, 'If I was a customer, would I buy from me?' If you use that as a formula, you will be successful."

By the early 2000s, with a renewed interest brought about by online betting and televised tournaments, poker had taken on a new lease on life. It was a stroke of luck that benefited Gardena, allowing the city's two casinos to coexist for sixteen years. The Hustler Casino attracted younger players, many of whom had been lured away from the training grounds of online poker to compete in live games of blackjack and Hold 'Em, while the Normandie Casino remained popular with older, more traditional Gardena players.

But after the depression of the late 2000s, a slowdown in disposable incomes, increased online gaming options and the rise of Indian tribal gaming resorts resulted in tougher times for card clubs. Shortly after opening the Hustler Casino, Flynt battled the state over Proposition 1A, a measure also known as the Gambling on Tribal Lands Amendment. Prop. 1A modified California's constitutional prohibition against casinos and lotteries, authorizing the governor to negotiate compacts with federally recognized Indian tribes, allowing them to operate slot machines, lotteries, banking

and percentage card games. These were effectively the same offerings found in Las Vegas—but instead on Indian lands in California. The measure prompted a forthcoming exponential explosion of tribal-run California casinos, only exceeded in scale by Nevada's casinos.

Flynt's protest against Prop. 1A was partially responsible for prompting his 2003 run for governor, during the recall of California governor Gray Davis. As he explained,

> *We've always tried to fight that. That was one reason why I ran for governor, not that I had any illusions of being elected. I just used the platform to try to get my point across that Indian gaming was unfair. And don't get me wrong, I don't care what the governor or the state give the Indians in terms of gaming privileges. But the private clubs in the rest of the state should have the same gaming. In other words, if the Indian reservations can have slot machines, we should be able to have slot machines. And I think it's unfair but the Indians put a lot of money into California politics, and so far, they've been able to have it their way.*

In more recent years, casinos everywhere have seen declining interest in poker. "Poker is collapsing as a casino game," said William Thompson, a professor of public administration at the University of Nevada–Las Vegas. During the fall of 2012, Las Vegas's Tropicana hotel-casino replaced its poker room with more profitable slot machines. Slot machines account for more than two-thirds of all casino revenue, with card games earning just a fraction of that. Case in point: in 2011, California card clubs took in $853 million. The state's Native American casinos—with their full-fledged casino offerings, including slot machines—collectively earned $6.9 billion.

In January 2016, a news story broke about an investigation of the Normandie Casino conducted by the IRS and the California Department of Justice's Bureau of Gambling Control that had resulted in a plea-bargaining agreement by the Normandie's four partners. According to the story, in 2013, the Normandie had hired promoters to lure in high rollers and failed to properly record and report a series of large-scale cash transactions. As a penalty, the club would now be forced to forfeit to the government $1,383,530 in unreported winnings. The violation of the Bank Secrecy Act stemmed from the fact that some big wins in the club had been reported as a series of small wins, with currency transaction reports recording each transaction as less than $10,000. Card clubs are required by law to report when customers use more than $10,000 in cash to buy poker chips.

A High-stakes History

Normandie Club chips. *Miller family archive.*

High-stakes Asian games, such as those that made up two-thirds of the Normandie's income, are particularly vulnerable to these violations, as high-rolling players often insist on strict privacy and bristle at having their transactions reported to the government. Betting in the club's Red Dragon Room had at times seen single hands range from $40,000 to $50,000. Really large games could see as much $500,000 on the table at one time.

In the plea agreement, filed in U.S. District Court, the Normandie agreed to plead guilty to two felonies: failing to maintain effective anti–money laundering measures by neglecting to file suspicious activity reports for the transactions over $5,000 and conspiring to avoid reporting large cash transactions to the government. Each felony received the maximum fine of $500,000, resulting in a combined federal fine of $1 million.

By late April 2016, speculation started to build in the press over rumors that Larry Flynt would be acquiring the Normandie Casino after reports circulated about a forced temporary shutdown until new ownership could be found to run the club. Under California law, felony convictions disqualify people from holding gaming licenses. The Millers' guilty plea—although no family members were convicted of a crime—had left the business owners in the unfortunate position of having their license revoked. The California

Normandie Casino's Red Dragon Room. *Miller family archive.*

Gambling Control Commission agreed to a 120-day grace period before revoking the license, allowing the Millers to operate the club while seeking a new buyer for their property.

Robert Turner, a poker player and casino manager intricately knowledgeable about the California card scene, commented:

> *It makes a lot of sense for Larry Flynt to* [buy the Normandie] *because he has a parking problem at the Hustler, and the Normandie sits on seventeen acres if you include the corner. If they build a hotel and convention area with a larger casino, they could give Hollywood Park Casino some competition. Hollywood Park is going to dominate the west side. What's happening there brings unbelievable potential to the area.*

That unbelievable potential for the west side was about to be unlocked by the return of the Los Angeles Rams, freshly relocated from St. Louis, with Inglewood's new football stadium and entertainment complex scheduled for completion in 2019. A move with seismic results for the community of Los Angeles card clubs, which now all planned to add major upgrades, including resort-style hotels and conference centers designed to cash in

on the area's future sports traffic. Turner lamented over the Normandie's pending sale, "It marks the end of an era. I think it's sad, but life moves on. It's the changing of the guard."

At a Gardena City Council meeting in mid-June 2016, the issue of approving the transfer of the Normandie Casino's license to a new card club enterprise titled "Larry Flynt's Lucky Lady Casino" was put on the agenda along with a debate over the tastefulness of proposed signage designs for the new club featuring a hostess posing provocatively. However, just as in signage debates of the past, the city attorney advised that, according to the city's ordinances, councilmembers had no say over the sign's content, only its size.

On July 7, 2016, the *Los Angeles Times* broke the news that Flynt had purchased the Normandie Casino license for an undisclosed sum, officially ending the era of Gardena's six-club monopoly. A dispute quickly erupted between the city council and Flynt over the new financial terms of his two clubs. In the past, Gardena had received 12 percent of the Normandie and Hustler's revenues, but there were now concerns that the city's share of the profits would be diminished. Card club taxes made up nearly one-fifth of the city's general operating revenue. In a surprise move, the city proposed a threshold $800,000 monthly tax for Flynt's clubs, which would nearly equal the $10 million in annual taxes the city had received from the clubs the prior year. In return, Flynt was offered a $256,000 loan and discounts on its 12 percent gaming revenue fee for months when the clubs earned more than $2 million each.

Flynt balked at the offer, adamantly rejecting the stipulation of having to make minimum monthly tax payments, as card club profits can vary wildly from month to month. His main objection was that the plan didn't take into consideration the potential of another economic downturn, after which a minimum tax obligation would render both properties unprofitable. Flynt's official rebuttal to the city came at the next council meeting, where he chastised the council:

> *The last time I was here to address the city was sixteen years ago when the council was objecting to me using the name "Hustler," a brand that I spent thirty years developing....Now in the sixteen years I've been here, I've paid this city $80.5 million! You would think that somebody that had done that much for this city and got so little in return—it's easy to see that I'm treated like a second-class citizen, and I don't like it one bit!*

Maintaining his poker face, Flynt threatened to take his offer off the table, bluffing, "Sometimes no deal is better than a bad deal....I'm walking away from it."

Soon after, the Lucky Lady Casino's grand opening was canceled, while city officials debated in private. Flynt meanwhile upped the ante by shutting down the club and suggested that he was exploring a third casino opportunity in Cudahy, telling the press, "That piece of junk sitting over there called the Normandie had been neglected for decades. It needs millions....I can't have the city breathing down my neck and making me guarantee that kind of revenue."

Flynt's high-stakes gamble paid off, and on July 20, the city council voted on the issue again. With dozens of employees from the shuttered Normandie Casino anxiously awaiting the club's fate filling the council chamber, councilmembers, who had previously voted 3–1 in favor of a minimum tax guarantee, now were unanimously reversing course in order to keep the deal alive. The council agreed to scrap the monthly guarantee provision and instead introduced a contractual provision that would allow them to renegotiate the deal if revenues dropped significantly at either of the casinos. The city would also reimburse Flynt for half of his tax payments if revenues exceeded $2 million a month, with 20 percent of that reimbursement considered a loan that would need to be repaid to the city after eight years. A spokesman for the Flynt Management Group indicated that the club, already undergoing small modifications, could open its doors in a matter of days.

Upon opening the club, Flynt voiced his optimism to the press:

> *I don't want to sound disparaging toward the previous owners on the fact that the place has been neglected for decades, but it has. That's the reason business was terrible. We're going to have new signage, a $400,000 media program across greater Los Angeles and more. I think the place will do fine....I think the city of Gardena will be proud of the club we're going to build.*

8
EPILOGUE

For all the talk of poker being on life support, Los Angeles seemed oblivious, as it was going through a major transformation, with expansions and renovations underway at card rooms throughout the county. The Commerce Casino had built itself up into a 240-table empire with recent renovations to its two-hundred-room Crowne Plaza Hotel and the addition of the Lucky Rabbit Party Pit, a poker room staffed with Playboy Bunny dealers and servers.

The Bicycle Casino and Hotel renovated its gaming facilities and added restaurants and suite-size hotel rooms, and the Gardens Casino in Hawaiian Gardens was working toward a goal of having three hundred table games, making it the largest poker hall in the world, offering over thirty-four high-limit poker games.

Hollywood Park Casino in Inglewood was also in the midst of a massive revitalization designed to make it the premier casino and entertainment destination in Southern California, with the world's most state-of-the-art poker room, movie theaters, condos, restaurants and a new retail complex anchored off a giant sports stadium that could play host to future Super Bowls when L.A.'s new NFL team, the Rams, took up residency.

By the summer of 2016, the image of Los Angeles's card clubs had become so ubiquitous that even a high-speed freeway police chase broadcast on the local evening news ended with a stolen pickup truck careening, with sparks flying from its burst tires, into the parking lot of Bell Gardens' Bicycle Hotel and Casino, grinding to a halt at police gunpoint.

Epilogue

With all of this in the works, in addition to Larry Flynt's two Gardena card clubs, and with over one thousand tables soon to be all within twenty minutes of each other, Los Angeles County stood poised on the brink of finding itself the undisputed capital of the poker universe.

SOURCES

Books

Dowling, Allen. *The Great American Pastime*. New York: A.S. Barnes and Company, 1970.
Hayano, David M. *Poker Faces: The Life and Work of Professional Card Players*. Berkeley: University of California Press, 1982.
Kling, Dwayne. *Biggest Little City: An Encyclopedic History of Reno Gaming, 1931–1981*. Reno: University of Nevada Press, 2000.
McManus, James. *Cowboys Full: The Story of Poker*. New York: Farrar, Straus and Giroux, 2009.
Moe, Albert W. *Nevada's Golden Age of Gambling: The Casinos 1931–1981*. Reno: Nevada Collectables, 1996.
Thompson, William N. *Gambling in America: An Encyclopedia of History, Issues, and Society*. Santa Barbara, CA: ABC-CLIO, 2001.

Newspapers

Anderson (IN) Daily Bulletin
Arcadia (California) Tribune
Asbury (NJ) Park Press
Bakersfield Californian
The Bee (Danville, VA)
Berkeley (CA) Daily Gazette
Breckenridge (TX) American
Daily Breeze (Los Angeles, CA)
Deseret (UT) News
Eugene (OR) Register-Guard
Gardena (CA) Record
Gardena (CA) Tribune
Gardena (CA) Valley News
Jasper (IN) Daily Herald
Las Vegas (NV) Review-Journal
Las Vegas (NV) Sun

Sources

Lewiston (ME) Daily Sun
Lewiston (ME) Evening Journal
Long Beach (CA) Independent
Long Beach (CA) Independent Press-Telegram
Long Beach (CA) Press-Telegram
Los Angeles Herald-Examiner
Los Angeles Mirror News
Los Angeles Sentinel
Los Angeles Times
Lubbock (TX) Morning Avalanche
Mercury News (San Francisco, CA)
Milwaukee (WI) Journal
Montreal (QC) Gazette
Nevada State Journal
New Mexico Lobo
New York Times
Oakland (CA) Tribune
Ogden (UT) Standard-Examiner
Orange County (CA) Register
Pasadena (CA) Independent Star News
Pasadena (CA) Star News
Pittsburgh (PA) Press
Reading-Eagle (Reading, PA)
Reno (NV) Evening Gazette
San Antonio (TX) Light
San Mateo (CA) Times
Schenectady (NY) Gazette
Sweetwater (TX) Reporter
The Times-News (Hendersonville, NC
Times Record (Troy, NY)
Torrance (CA) Herald
Tucson (AZ) Daily Citizen
Utica (NY) Daily Press

Magazines

California History 59, no. 4, Winter 1980–81.
Casino Chip & Token News 23, no. 2, 2010.
Life. April 26, 1954.
Poker Player 1, no. 4, December 27, 1982.
Transworld Motocross. April 23, 2004.

Internet Sources

Beatty, Darrel, "The Father of Poker Clubs in Gardena." Facebook.com, November 14, 2015.
———. "Shooting in Gardena 29 Poker Players Wounded." Facebook.com, December 15, 2015.
Turner, Robert. "Gardena: Poker Capital of the World." RobertTurnerPoker.wordpress.com, April 24, 2016.
———. "Los Angeles Poker Explosion." RobertTurnerPoker.wordpress.com, July 21, 2016.

Sources

Legal Records

Broffman v. Klassman. Civ. No. 24447. Second Dist., Div. One. July 25, 1960.

Harry and Beverly Klassman Appeal before the California State Board of Equalization, 62-SBE-003. February 13, 1962.

Investigation of Organized Crime in Interstate Commerce, Hearings Before the Special Committee to Investigate Organized Crime in Interstate Commerce, Part 10, Nevada and California.

Monterey Club v. Superior Court. Civ. No. 13030. Second Dist., Div. One. April 21, 1941.

Monterey Club v. Superior Court. Civ. No. 13189. Second Dist., Div. One. November 28, 1941.

People v. Gilbert. 22 Cal.2d 522, California Supreme Court Resources. July 14, 1943.

People v. Philbin. Crim. A No. 1862, California Court of Appeal Opinion. March 9, 1942.

Primm v. Primm. 46 Cal.2d 690, California Supreme Court Resources. June 28, 1956.

Sonksen v. Primm. No. 3843 281 P.2d 987, Supreme Court of Nevada. April 7, 1955.

Webb, Attorney General Ulysses. "Draw Poker Legality" Opinion Letter. March 1, 1937.

Interviews by the Author

Bernstein, Bea. Gardena, California. September 10, 2008.
Dear, Don. Gardena, California. November 23, 26, 2007.
Flynt, Larry. Beverly Hills, California. April 18, 2008.
Greaton, Don. Gardena, California. December 1, 2007.
Greco, Larry. Gardena, California. January 28, 2007.
Greco, Paul. Gardena, California. January 28, 2007.
Holt, Loyce. Gardena, California. April 1, 2008.
Leslie-Laretto, Barbara. Gardena, California. September 24, 2008.
Miller, Steve. Gardena, California. September 24, 2008.
Miller-Wahler, Michelle. Gardena, California. September 24, 2008.
Nakaoka, Grant. Gardena, California. April 24, 2008.
Nicholson, Blaine. San Diego, California. January 3, 2008.
Osbourne, Jim. Lawndale, California. November 7, 2008.
Osbourne, Laura. Lawndale, California. November 7, 2008.
Parks, Tom. Gardena, California. March 15, 2007.
———. Golden State Gaming Association Hall of Fame Awards Speech. Berkeley, California. October 27, 2008.
Russ, Edmond. Gardena, California. April 21, 2008.
Thomas, Betty. Gardena, California. April 2, 2008.

INDEX

A

American Legion 29, 30, 32, 38, 39, 40, 41, 42, 43, 44, 73, 80, 81, 124
AmVets 73, 74, 77, 78, 79, 80, 84
Anthony, George 100, 101, 104, 105, 107, 111, 114, 119, 120, 122, 127, 132, 135, 139, 145

B

Beverly Hills 37, 53, 58, 91, 100, 106, 128, 139, 141
Bicycle Club 121, 124, 151
Blackjack 126, 145
Bogart, Wayne 11, 19, 22, 23, 28
Bolton, Adams 33, 34, 35, 61, 66, 67, 71, 72, 75, 76, 78, 84
B or Better Foundation 145

C

California Bell Club 117, 132
Carrell, Frank 13, 14, 19, 24, 27, 28, 29, 37
Casino Club 29, 30, 32, 37, 38, 39, 40, 41, 42, 43
Century City 53, 108, 127, 135, 139
chip girls 91, 110, 118, 145

Civic Improvement Committee 61, 68
Civic Improvement League 68, 69, 70, 74
Cohen, Mickey 13, 28
Colony Club 10, 45, 46
Commerce Casino 120, 126, 133, 151
Compton 45, 77, 81, 136
Contreras, George 13, 14, 18
Cornero, Tony 37, 41, 42
Cudahy 91, 150

D

Dear, Don 102, 129, 136
Dear, Donald 105
draw poker 12, 16, 17, 18, 20, 21, 22, 24, 34, 35, 69

E

Edgemont Club 9
Eldorado Club 100, 101, 104, 111, 127, 135, 139, 141, 142
Embassy Club 24, 28, 31, 51, 55, 63, 65, 66, 67, 72, 91, 99, 108, 145
Embassy Palace 11, 13, 14, 15, 16, 17, 18, 19, 20, 21, 37, 38
Embassy Theatre 11, 21

INDEX

F

Field, Elmo 18, 20, 23, 27, 29, 32, 44, 62, 87
Flynt, Larry 139, 140, 141, 142, 145, 147, 148, 149, 150, 152
F&O Confectionery 12, 13
Fortune Club 29, 32, 42, 44, 50

G

Gardena Club 20, 21, 23, 28, 35, 42, 46, 58, 66, 72, 80, 85, 88, 89, 93, 101, 124
Gardena Fun Day Club 86
Gardena Ministerial Association 11, 33, 34, 76, 81, 142
Gardena Municipal Bus Line 34, 87
Gardena Taxpayers Fact Finding Committee 70, 81
Gardena Valley News 12, 24, 25, 35, 41, 56, 68, 69, 70, 77, 80, 81
Gardena Yellow Cab company 61, 62, 66
Gardena Youth Authority 80
Greco, Paul 107, 108, 109, 110
Guarantee Finance Corporation 47

H

Hall, Joe 11, 50, 52, 53, 73, 79, 81, 85, 101, 108
Hawthorne 18, 20, 21, 25, 53, 114
Herbert, Bow 39, 42, 43, 44, 67, 68, 78, 80, 81, 85, 101, 102, 106
Hoffa, Jimmy 111, 113
Hollywood 9, 46, 51, 88, 119, 135
Hollywood Park Casino 135, 148, 151
Horseshoe Club 41, 42, 43, 44, 48, 58, 75, 80, 81, 97, 105, 106, 121, 124, 126, 131, 133
Huntington Park Casino 124, 126, 132
Hustler Casino 11, 142, 143, 144, 145

I

Inglewood 13, 46, 80, 101, 114, 115, 135, 148, 151

K

Kefauver Committee 43, 140
Klassman, Harry 55, 63, 65, 66, 67, 68, 72, 91, 99, 101
Koullapis, Louis 95, 96, 97, 98, 99

L

LAPD 11, 26, 31, 47
Las Vegas 9, 11, 12, 49, 53, 56, 74, 75, 85, 93, 108, 132, 136, 138, 146
Los Angeles Times 10, 81, 85, 115, 129, 149
low ball 21, 144
Lucky Lady Casino 150

M

Marks, Sid 88
Martin, Frankie 9, 11, 13, 15, 17, 19, 21, 23, 37, 47, 55, 91
Miller, Mary Ellen 145
Miller, Russ 9, 11, 12, 21, 23, 47, 52, 53, 91, 101, 108, 124, 126, 144, 145
Monterey Club 21, 22, 23, 24, 28, 29, 36, 37, 46, 47, 52, 54, 55, 57, 63, 64, 65, 66, 82, 83, 84, 97, 117, 119

N

Nakaoka, Ken 102, 105, 106
Nicholson, Blaine 28, 50, 86, 87, 95, 114, 129, 131
Nisei VFW 73, 77, 78, 79, 80, 84
Normandie Club 9, 29, 31, 45, 46, 48, 52, 53, 54, 76, 79, 93, 101, 102, 107, 108, 109, 129, 131, 133, 134, 135, 139, 144, 145, 146, 147, 149, 150

Index

P

pai gow 124, 126, 144
Palace Club 28, 46
panguingue 106, 126, 144
Parker, William 11, 43, 44, 46, 48
Parks, Tom 78, 80, 95, 106, 117, 119, 120
Primadonna 50, 114, 116, 129, 136
Primm, Ernie 9, 11, 12, 16, 19, 20, 22, 23, 28, 36, 38, 47, 49, 50, 54, 55, 63, 67, 71, 72, 75, 81, 83, 86, 91, 101, 104, 105, 113, 114, 116, 129, 136, 144
Primm, Evelyn Johnson 71, 72, 113
Primm, Gary 113, 114, 121, 136
Primm, Josephine Schmitz 12, 46
Proposition 13 116, 117

R

Rainbow Club 52, 56, 57, 58, 60, 62, 63, 79, 82, 83, 84, 96, 97, 119, 120, 121, 122
Reno 28, 46, 49, 50, 56, 87, 113, 114, 116, 129
Rummel, Norma 52
Rummel, Sammy 13, 14, 16, 19, 22, 23, 32, 46, 47, 48, 49
Russ, Edmond 74, 102, 105, 122, 127, 134

S

seven-card stud 107, 132, 144
Shaw, Frank 10
Skillo 11, 13, 14, 15, 16
Starlite Club 81, 85
stud horse poker 16

T

Tango 11, 14
Texas Hold 'Em 132, 144, 145
Torrance 18, 37, 139
Town Magazine 86

Tracey, Roy 31, 82, 87
Twin Palms Club 25, 26, 27

V

Van Der Steen, Bernard 52, 53, 76, 79, 91, 101
Ver-Crans Corporation 39, 41, 42, 43, 44
VFW 29, 42, 44, 52, 55, 60, 73

W

Webb, Ulysses 14, 16, 18
Western Club 20, 28, 29, 50, 51, 52, 55, 59
Whisky Pete's 114, 116, 121, 138

ABOUT THE AUTHOR

Max Votolato, born and raised in London, has worked in the Los Angeles film industry for fifteen years, including posts at Paramount, MGM, KingSports and the Fox television series *Cosmos: A Spacetime Odyssey*. His 2015 documentary film *Freeway City* introduced the history of Gardena's card clubs, the starting point for this story.

For more information, please visit www.FreewayCity.org or follow the author on Twitter: @Votolato